KALAGAS
THE WALL HANGINGS OF SOUTHEAST ASIA

Published by:

Ainslie's, P.O. Box 7656, Menlo Park, CA 94026–7656

ISBN Number. 0-9618445-0-7

Copyright 1987 Mary Anne Stanislaw

Copyright Photographs 1987 Robert Stedman

Printed and designed in Singapore

KALAGAS

THE WALL HANGINGS OF SOUTHEAST ASIA

BY

MARY ANNE STANISLAW

PHOTOGRAPHS
BY

ROBERT STEDMAN

To my mother, Joanna Cross
Without your encouragement, this book would not be possible.
This "lost" art form has been revived because of your interest.
Thank you for allowing us and future generations
the pleasure of enjoying these treasures.

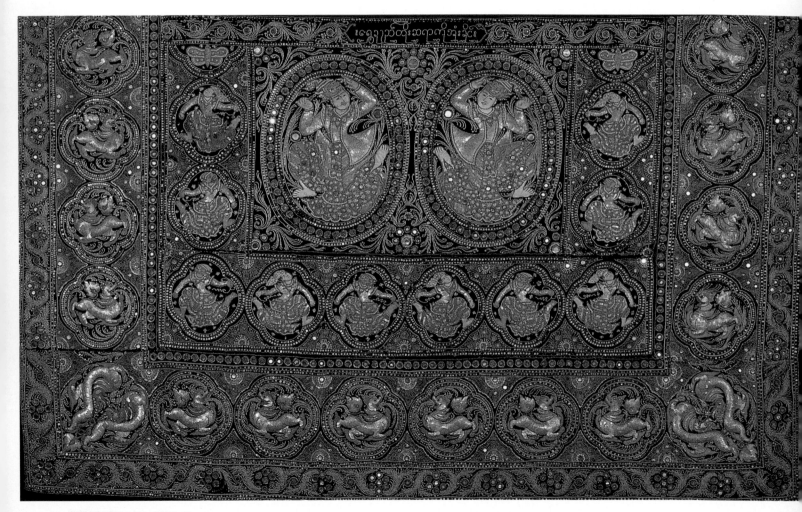

RAMAYANA circa 1830, Burma.
Collection: Barrie V. Cross,
Bangkok

KALAGAS – THE WALL HANGINGS OF SOUTHEAST ASIA

PREFACE . 1

CHRONOLOGY . 3

HISTORY OF THE KALAGA . 4

MAKING OF THE KALAGA . 10

LEGENDS AND MYTHOLOGY . 12

I The Ten Jataka Tales — The Tosachat 13

 1. Temiya — Renunciation . 14
 2. Mahajanaka — Perseverance 16
 3. Sama — Devotion . 19
 4. Nemi — Resolution . 20
 5. Mahosadha — Wisdom . 22
 6. Bhuridatta — Moral Practice 24
 7. Candakumara — Forbearance 26
 8. Narada — Equanimity . 28
 9. Vidhura-Pandita — Truth . 30
 10. Vessantara — Charity . 32

II The Life of Prince Siddharta . 35

III The Gods of the Planets . 38

IV The Animals of the Buddhist Years 39

V Horoscopes . 45

VI Burmese Nats . 46

VII The Ramayana . 51

VIII Folk Tales . 53

IX Ceremonies . 54

X Mythical Animals . 55

XI Animals . 59

EPILOGUE . 62

BIBLIOGRAPHY . 63

PREFACE

Over thirty five years ago, my grandmother, Connie Mangskau, established Monogram Co. Ltd. and thus became one of the first antique dealers in Thailand. She has known a great life as grande dame of Bangkok society and has been a model to all of her grandchildren in her endeavors to teach us something about the culture and beauty of Thailand. My earliest memories of the busy Monogram Shop and the reconstruction of the Thai House, featured my grandmother on the spot, directing the whole operation. In 1960 she and her good friend Jim Thompson decided to rebuild antique Thai houses, grouping them together so that they would accomodate more rooms for a modern family, rather than just the one large room where everyone lived and slept. Jim built his house first and came across many problems. When he was ready to reconstruct my grandmother's house, he had found solutions to all of the problems previously encountered. The antique houses were taken apart like a puzzle, Jim alphabetized each wall of teak and had all of the parts shipped to Bangkok from Ayuddhya by rice barge. It was no simple task reassembling the houses. The klongs in the compounds needed to be filled, but after each truck load of earth, the skies seemed to open and deluge us with a particularly violent monsoon. With each new turn of events, the workers would stare blankly, scratch their heads and try their best to fathom what this foreigner was trying to create. In our childhood glee, my brother and I were prone to create havoc, purposely misplacing parts of the giant puzzle or simply hiding the tiles of the roof, all of which created many unforeseen delays. In spite of our foolish pranks, the house was successfully completed and has served as a blueprint for many reconstructed and new Thai houses all over the country. My mother moved into the house many years ago and has modernized it and made it our comfortable family home without taking away from the original charm.

Both my father and mother were very interested in the history of Thailand, and many a Sunday afternoon, we visited ruins in Ayuddhya, Prabat, Pimai and Nakorn Pathom. My father, a keen collector of Buddhist art, made me recite the periods of Thai art even before I could read or write very well. This interest, which started so early in my life, has taken me to many parts of the world and led me to read volumes in many different languages on Southeast Asian history and art. My mother has always been a collector, and has a way of studying each piece and committing it to her memory. Years after seeing a beautiful object, she is still able to describe it perfectly. This is perhaps due to her artistic eye, as she is an accomplished artist in the Chinese School.

During the 1970's, I first discovered Kalagas. It was during a trip with my grandmother to Chiengmai, and although I was still a teenager, I was fascinated with these beautiful antiques which had made their way from Mandalay, Burma to Thailand. In 1979, I returned to Thailand, having completed my studies in Europe, to join my mother's branch of Monogram. In 1980, my grandmother decided to retire and we closed the Erawan shop to open another store at the Oriental.

Over the years, my mother had been collecting kalagas, and the antique pieces were becoming very scarce. It was at this time that we became involved, through intermediaries, in having new kalagas made. First we began with one family, keeping the same traditional patterns and copying the muted colors of the antique ones. We

persevered, time and again, as the early pieces were not beautiful enough. My mother went about her business on a day to day basis, hoping that, soon, the kalaga makers would be able to recapture the beauty of the antique ones. As time went on, we began having smaller ones made so that they would fit into modern homes, and during the next years, the cottage industry grew. Today kalaga making has become another handicraft for many families in Burma and Thailand.

In 1985, I began importing to the United States, and in 1986 I held trunk shows at most of the Neiman Marcus stores, selling kalagas, and talking about them to the American public. Before my first show, I began writing the stories told in the kalagas, and suddenly, the stories grew into a book. At the request of so many people I met all over the United States, I am writing this book to share the wonderful stories that the kalagas tell.

It is impossible to tell these beautiful stories without mentioning the religion that inspired so many of them. Both Burma and Thailand are devout Theravada Buddhist lands, and many of the stories depicted in the Kalagas come from the Ten Lives of the Buddha. Some depict scenes from the Ramayana, the famous epic poem written in India over 2,000 years ago, and adapted to each Southeast Asian country's dances and drama. In some cases, the stories are folk tales, passed on only by word of mouth. The Ten Lives of the Buddha are perhaps my favorites, they are often full of magic and miracles. In each life the Buddha perfected a virtue, and in recounting these stories, I hope we will be reminded to lead our lives as virtuously as possible.

The beautiful photography for this book is the work of Robert Stedman, a young American who lives in Singapore. Robert has not only photographed all of the work in this book, but was instrumental in the visual concept and graphic design. Without Robert and his strive for excellence, this book would not have been published. My sincere thanks to Robert and all of his associates who helped in the creation of this book. My special thanks to my brother, James Stanislaw, for putting in so many long hours editing my work. My gratitude goes to all the staff at Monogram Antiques, Oriental Hotel, Bangkok, who worked long hours to help me select the Kalagas for photography. All kalagas were loaned by Monogram Antiques, unless otherwise stated.

Mary Anne Stanislaw, Menlo Park, California, June 1987

CHRONOLOGY

2500 B.C.	T'AIS RESIDING IN THE YELLOW BASIN AREA OF CHINA
2,208 B.C.	CHINESE BEGIN ABSORBING T'AIS
1–600 A.D.	T'AIS BEGIN TO MIGRATE SOUTH
651	KINGDOM OF NANCHAO IS ESTABLISHED (NORTH AND WEST YUNNAN)
730–748	NANCHAO KINGDOM IS UNITED UNDER PI-LO-KO
800–1100	GREAT MIGRATION OF T'AIS SOUTH
1238	T'AIS OVERTHROW KHMERS AND ESTABLISH SUKOTHAI KINGDOM
1253	FINAL DEFEAT OF THE NANCHAO KINGDOM BY KUBLAI KHAN
1283–84	CHINESE INVADE BURMA WITH SHANS
1286–88	SECOND INVASION
1296	LAN NA T'AI KING MENGRAI QUASHED FINAL REBELLION IN THE MON STATE OF HARIPUNJAYA, AND EXILE KING YI BA
1351–1569	AYUDDHYA BECOMES THE DOMINANT T'AI KINGDOM
1378	SUKOTHAI BECOMES A VASSAL TO THE T'AI STATE OF AYUDDHYA
1767	AYUDDHYA IS SACKED AND DESTROYED BY THE BURMESE
1767	GENERAL TAKSIN ESTABLISHED THE T'AI CAPITAL AT THONBURI
1782	CHAKRI DYNASTY ESTABLISHED IN BANGKOK

HISTORY OF THE KALAGA

KALAGA, a word derived from Sanskrit, means "Foreign Curtain". Immediately this raises the question — Foreign to whom?

In recent history, kalagas were made as early as 1830 until approximately 1878 in Burma, mainly during the reign of King Mindon of Mandalay, particularly during the later years after King Mindon moved his capital from Amarapura to Mandalay.

During the entire Ayuddhya period in Thailand, until the destruction of the capital in 1767 by the Burmese, Thai culture very much influenced the Burmese courts. King Mindon had Shan workers in his palace making kalagas. Shans are the same ethnic race as the Thais, inhabiting a large area of Burma, but are considered foreigners in Burma. Perhaps for this reason, these wall hangings were dubbed "Foreign Curtains" by the Burmese.

At this time, trade with the British was booming, and many kalagas were made for export to Europe. Some of these kalagas were even produced with European faces, and scenes that were more likely for uses in European palaces than in Asian ones. But this artform never caught on in Europe and it was soon to be forgotten in Burma too, with the exception of one or two families who were still able to make them.

In order to trace the earliest kalagas, we must trace the earliest mentions of the T'ai race, as they seem to be linked as far back as the 1st Century A.D. The Thais of Thailand are of the same ethnic group as the early T'ai, the Shans of Burma, the Lao in Laos, the Tai Dum, Tai Dang, Tai Khao and Nung in Tonkin and Annam (Vietnam). Even to this day, a section of the Yunnan province in China is inhabited by approximately 500,000 T'ais who share the same culture and customs as all of the other cousin T'ais.

During the 1st Century A.D. we find the T'ais in the Western Yunnan. Under the leadership of Pi-lo-ko (730–748), Prince of the Nan Chao, control was

NATS ON PENSARUPA, new

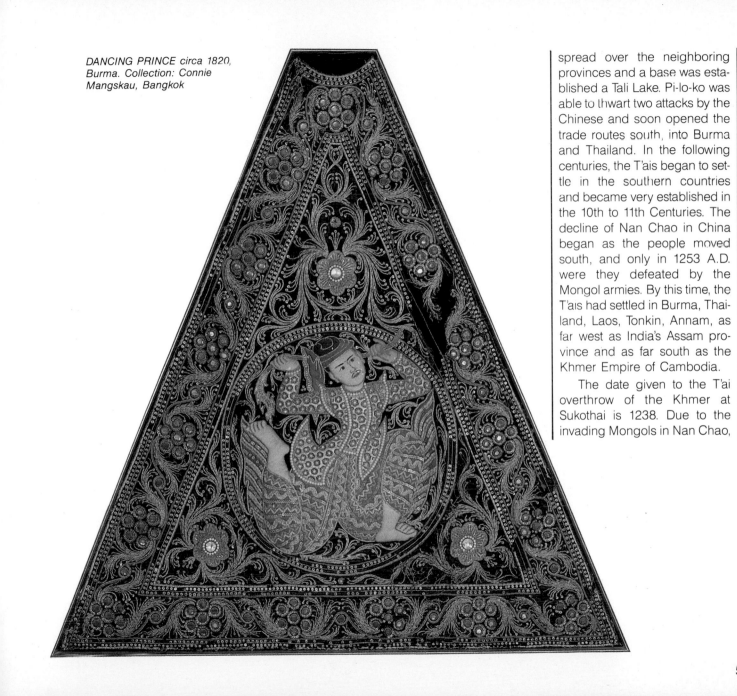

DANCING PRINCE circa 1820, Burma. Collection: Connie Mangskau, Bangkok

spread over the neighboring provinces and a base was established a Tali Lake. Pi-lo-ko was able to thwart two attacks by the Chinese and soon opened the trade routes south, into Burma and Thailand. In the following centuries, the T'ais began to settle in the southern countries and became very established in the 10th to 11th Centuries. The decline of Nan Chao in China began as the people moved south, and only in 1253 A.D. were they defeated by the Mongol armies. By this time, the T'ais had settled in Burma, Thailand, Laos, Tonkin, Annam, as far west as India's Assam province and as far south as the Khmer Empire of Cambodia.

The date given to the T'ai overthrow of the Khmer at Sukothai is 1238. Due to the invading Mongols in Nan Chao,

5

the southern migration of the T'ais was much more important than that of earlier centuries. With the new T'ai kingdom at Sukothai, the warriors set out to conquer, and were successful in capturing the Mon state of Haripunjaya in 1296. The kingdom of Lanna with its seat in Chiangmai was established in that year.

It is from the kingdom of Sukothai, that the modern Thai nation can be traced. Indeed, it is here that the T'ais were finally free from foreign rule and in order to distinguish themselves from all of the group of T'ai speakers, they took the name Thai. This fabled kingdom of Sukothai is often called the cradle of Thai civilization. Some of the most beautiful sculptures of the Buddha were made during this period. Exquisite celadon pottery was perfected here in nearby kilns. In the last few years, more and more discoveries have been made, which now lead archeologists to believe that this type of pottery actually originated here and moved north to China. The Thai alphabet was also written during this time by King Ramkamhaeng. Finally, in 1378, Sukothai, weakened by political strife, became a vassal of the neighboring Thai kingdom of Ayuddhya.

During these early days in the kingdom of Sukothai, the earliest court costumes appeared. With the beautiful embroidery, brocades and designs, the costumes became more luxurious as time went by. In Ayuddhya, the Thai culture became a source of envy for all neighboring kingdoms. From 1367–1767, Burma was perhaps the most jealous neighbor, fighting war after war with the Thais. Prisoners were taken, especially dancers and court attendants, so that the Burmese could emulate the grace of the Thais. During this period, the Thais traded openly with the Dutch and Portuguese, and it was around this time that foreign faces first appeared in temple murals. Unfortunately, with the seige and destruction of Ayuddhya by the Burmese in 1767, very little remains of the splendor of the court of the Thais.

In some of the earlier Ratanakosin (Bangkok) bronze sculptures, exact court costumes are reproduced with a heavy beading and quilting effect that remain a testament to what must have existed in Ayuddhya. It is my belief that Ayuddhya directly influenced much of the work in the early Burmese kalagas. It has also been noted that most of the kalagas were found in the Shan states in the early 1900's, which would explain the link of the mirror-like glass found in these kalagas. These resemble the same type of work found in southern China, rather than similar work from India. The earliest needlework in China came from the Yangtse River basin, just north of the Yunnan, at the time of the Nan Chao kingdom.

In most of the southern Chinese, northern Indian tribes, some type of wall hanging existed, and still exists. Initially used as insulation, it later became an art form. The very earliest examples of applique date back some three thousand years, to Egyptian times. It is therefore my opinion that the kalaga was conceived at least two thousand years ago, in the Nan Chao kingdom. Of course, over the centuries, this art form was lost many times, but just the construction, the way in which it is so simple to fold the hangings, forces me to believe that these cloths were made long ago so that they could travel with their owners as they moved from place to place.

Today the dancing costumes in Thailand are a legacy to the court costumes of the past. A silver mixture is used for sequins,

as the sequins used in kalagas, and metallic threads are used to make simple stitches on the costumes, which again resemble the work on kalagas. The type of silver work used in the making of the kalaga is traditional to the northern Thai, southern Chinese regions, where the tribes still make buttons and jewellery of this mixture. During the great Mandalay influence on the kalaga, definite European influences are noticeable. On some of the antique kalagas, I have found devas or angels with very Italian looking wings. Also in some of the faces, one detects and influence of the Persians.

Some of the most beautiful antique kalagas are found in private collections today, and most of these were probably made at the palace in Mandalay, during the reign of King Mindon.

CLOSE-UP OF A DANCING PRINCE, new.
This is a border motif.

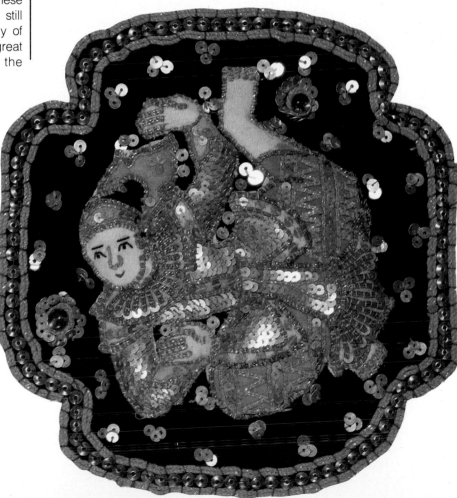

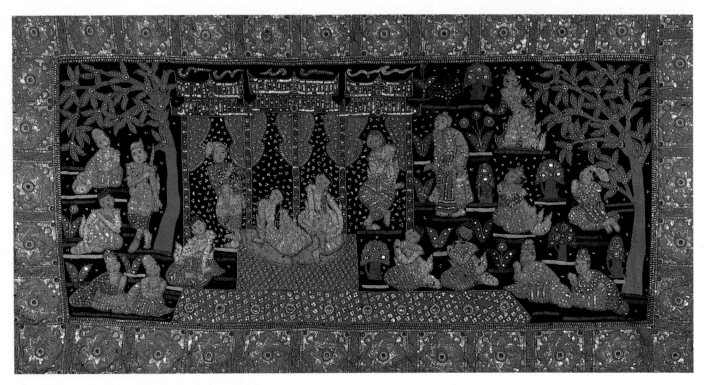

PRINCE SIDDHARTHA'S WEDDING early 1900's

FAMILY MAKING A KALAGA

MAKING OF THE KALAGA

The kalaga is a masterpiece of applique. This is a beautiful form of needlework and was practiced as long ago as three thousand years in ancient Egypt. Simply, it is a cut out design of cloth, applied to a base cloth and sewn on. But kalaga applique is embellished by embroidery, sequins, beads and thick nubby threads. The stitches are not necessarily difficult ones as it is the play of light on the appliqued and often quilted pieces that are the central focus of the kalaga. Quilting gives the hanging more depth and dimension as the figures burst forth from the kalaga with energy not found in flat embroidery.

There are three steps to the assembling of a kalaga:

1. The preparation of the base cloth
2. The preparation of the figures
3. The application of the figures to the base cloth and embellishment

Once the size of the base cloth has been determined, and a theme chosen, the figures or characters of the theme are drawn free hand on a stretched canvas, and the sequins and threads are applied to each figure, forming it's shape and decoration. At the same time, the base cloth is prepared, with designs chalked in. It is over these chalked patterns that the application of sequins and stones is done. Each sequin is sewn into the piece as are all of the stones. Once the base cloth is ready, the finished figures are applied to the cloth, being stuffed as they are being sewn. In the last steps, pretty stitches in swirls are made to cover any of the remaining base cloth.

Each kalaga is conceived by a member of each family who I call the "artistic director". He or she is the person who directs the piece, giving the tasks to the others, and chalking the designs. On the base cloth, work begins from the outside in. Rows of sequins, threads and stones are applied leaving the center for a single figure or a scene, depending on the size. The figures are stuffed with kapok, an indigenous fiber that is plentiful in Burma and Thailand. As I mentioned above, the figures are stuffed as they are being applied. This is, in fact, very difficult work, but it is important to keep the base cloth whole and not to cut it as sometimes happens in trapunto work. The weight of the figures, laden with silver sequins and stuffed with kapok, requires that the base cloth be properly stretched should one wish to frame a modern kalaga. In many of the antique pieces, no stuffing was used, so it is not necessary to stretch the cloth as strongly, but proper backing and mounting is necessary to preserve the fabric.

Once the kalaga is finished, a border is sewn around it. All of the threads used in the modern kalagas have been hand dyed to match each piece. This is in keeping with the ancient traditions. The sequins are a hand hammered silver mixture, which look like pewter. The stones are glass beads, also handmade, then colored underneath, glued onto a square piece of glass or mirror and sewn into the kalaga. In some cases, mother of pearl is fashioned into beads and sewn into the kalaga. Every kalaga made today is still crafted in the traditional manner and many of the new ones are far more beautiful than the ones made long ago.

BUDDHIST SHRINE early 1900's, Burma. This piece is interesting in the composition of the pillars and the alternating colors on the floor and ceiling. Collection: Joanna Cross, Bangkok

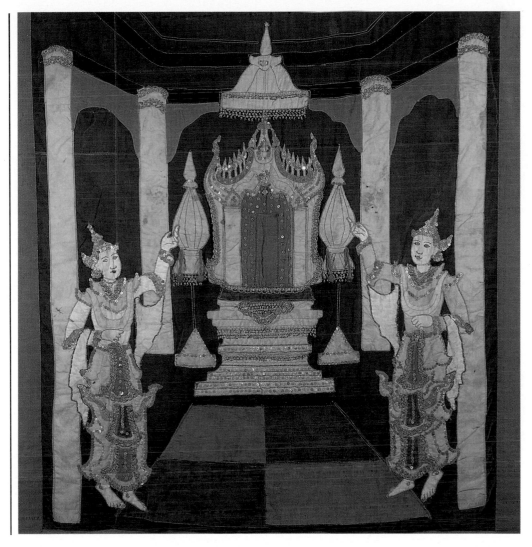

LEGENDS AND MYTHOLOGY

THE TEN JATAKA TALES OR THE TOSACHAT

Before beginning the actual tales, it is important to know a little about the great ten lives of the Buddha. The Buddha lived 550 lives, but in Theravada Buddhism only the last ten are recounted very often. In each life, the Buddha perfected one virtue until the last life as Prince Vessantara, which is the culmination of his perfection as a mortal. He was then born as Prince Siddhartha and attained Buddhahood. Although these stories have religious roots, they are full of wonder, magic and miracles. Men and gods often leave their realms to visit the heavens or hells, and demons sometimes disguise themselves as men.

Each of the jatakas are different, and I'm sure you will find a favorite story. The one which has inspired me since childhood is the Sama jataka. A beautiful painting of Sama being shot with an arrow while fetching water, hung in my grandmother's dining room. The artist captured the tranquility of the forest, the grace of the animals and the youth's innocent face suddenly pierced with pain so well that I was compelled to ask my great grandmother to tell me the story behind this sad scene again and again. As Great Granny told me the story she reminded me to follow Sama's good example and be devoted to my parents. Alas such a task was anything but easy, but I was profoundly moved by the jataka. The painting now hangs in my living room, and each time I look at it, I think fondly of my Great Granny chiding me to be the devoted child my parents deserve.

If you believe in re-incarnation and the existence of other planes, you will find the jataka tales enlightening. If you do not, you will find them none the less entertaining.

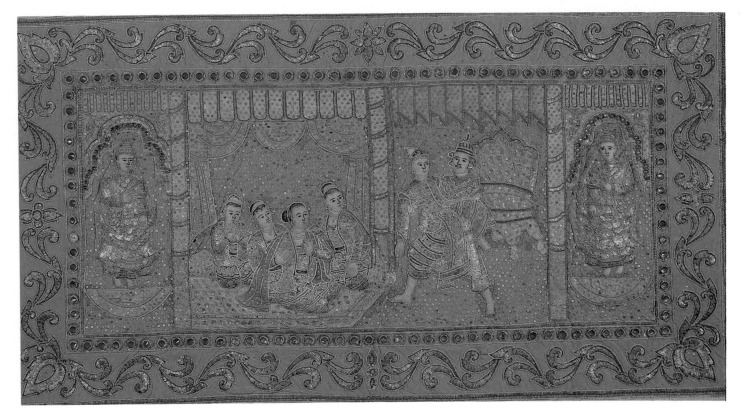

TEMIYA IS CARRIED INTO A PERFUMED CHAMBER, new

1. PRINCE TEMIYA

Renunciation
(Self Abnegation)

Long ago in Benares, on an auspicious rainy day, the virtuous Queen Candadevi gave birth to a son who she named Temiya-Kumaro. Her husband King Kasiraja was so pleased with his firstborn child, that he generously granted the Queen any request she wished to make of him. However, the wise Queen preferred to wait until it would really be necessary to make a request of her husband.

When Prince Temiya was but a month old, his father took him on his lap as he held audiences with his subjects. Prince Temiya watched his father condemn some prisoners to very harsh and severe punishments, and he became very frightened. The baby Prince knew that his father would have to suffer tens of thousands of years in hell for condemning men to torture and death. The infant thought of his future as king, and the punishments he would have to bestow. He remembered an earlier life as the King of Benares, when he reigned for twenty years and was condemned to eighty thousand years in hell. As the troubled infant planned an escape in his mind, a goddess spoke to him saying that he should pretend to be a crippled mute, never using his voice or limbs, so that the people would never crown him king. Prince Temiya agreed to do this, and immediately began to show signs that he was different than other children.

The King worried about his son, and tried to find the cause of his son's sickness. He put the boy through many tests, but nothing made Temiya move. He never cried, never showed fear and never laughed. Finally when he was sixteen, his father led him to a perfumed chamber with the most beautiful maidens in the kingdom to entice him to move, but Temiya was not weakened by these temptations. The fortune tellers of the court predicted that Temiya was not fit to be King and would bring much bad luck to the kingdom if he was allowed to live. They convinced the King to put him to death, and with reluctance, the King agreed.

Queen Candadevi remembered that the King had granted her a wish at the birth of her son, and asked him to spare Temiya. The King agreed to spare Temiya's life but only for seven days, and if he did not speak at the end of the seventh day, he would be put to death. Each day, the poor Queen begged and pleaded with her son to speak, but he remained silent. On the seventh day preparations were made for Temiya's death. Ill-omened horses and a chariot were used to take him to the burial grounds, and the charioteer began to dig Prince Temiya's grave. Now that the Prince's royal ornaments had been removed and he was finally free of the palace walls, he decided to test his strength, and move the limbs that had remained motionless for sixteen years. He seized the chariot with one hand and raised it over his head as if it were made of paper.

The charioteer was startled by this display and bowed to Prince Temiya, offering to escort him back to the Palace. But the Prince announced his wish to spend the rest of his life as an ascetic. The servant returned to the palace and explained to the King and Queen the wonderful show of strength he witnessed, and that the Prince spoke to him, revealing himself as a Bodhisattva. The King and Queen were so pleased with this news that they decided to follow their son's example. They disposed of all their worldly goods to become ascetics and live in the woods with Temiya.

2. MAHAJANAKA

Preserverence

King Mahajanaka of Mithila had two sons, Aritthajanaka and Polajanaka. When the king died, Aritthajanaka, the eldest son became King, and Polajanaka his viceroy. Very soon trouble began to brew as King Aritthjanaka was jealous of his brother and took him to battle. But the King was killed and his Queen fled when she heard of his death. The sad Queen was carrying a child deemed to be a Great Being or Bodhisattva. With the help of Sakka, the god of Tavitsama heaven, the Queen was led to safety and refuge with a Brahmin. She told him who she was, and he promised that he would take care of her and her child. When the child was born, she named him after his grandfather, Mahajanaka.

One day, the boy returned home to ask his mother who his father was. She explained about the battle and told him his father was King Aritthajanaka, the former king of Mithila. The young prince dreamt of regaining the throne, and when he turned sixteen, he took the jewels his mother had kept all these years and boarded a ship for Suvannabhumi to make his fortune. In the middle of the stormy seas, he was shipwrecked, and unlikely as it was for the Prince to survive in the tumultuous ocean, the Prince persisted in swimming for seven days.

The goddess of the seas, Manimehkala was visiting heaven and neglected her duties as guardian of the ocean. Finally she noticed Prince Mahajanaka and gathered him into her arms. During the seven days that the young Prince was swimming in the ocean, his uncle King Polajanaka passed away, leaving the throne of Mithila open. Manimehkala took Prince Mahajanaka to a mango grove near the palace, where he was found by some of the King's men. They immediately noticed that the sleeping boy had auspicious marks on the soles of his feet and took him to the palace to crown him King.

His uncle, had no son of his own, but had a beautiful daughter, named Princess Sivali. In order to be crowned King, he had to win her heart and overcome certain tests. He was asked riddles, which he solved with wisdom and ease, and was able to string his uncle's bow, fulfilling yet another condition to become King. Mahajanaka had ignored Sivali, showing no concern or interest. But the beautiful Princess could not bear his indifference, and one morning in the garden, she approached him, and gave him her arm. Thus Mahajanaka fulfilled all of the conditions, and was crowned King, with Sivali as his Queen.

For many years, King Mahajanaka ruled his kingdom very wisely, and his lovely wife gave birth to a son. On his son's sixteenth birthday, the Prince was made viceroy, and King Mahajanaka began to reflect on the fact that only the mango trees that bear much fruit are constantly being plundered. Those that bear no fruit are left alone. Contemplating this, he reached his decision to give up his life as King and to become an ascetic. The Queen followed him and tried to change his mind. But after many encounters, Mahajanaka told her that as a reed cannot be joined once broken, neither could they be joined again. Mahajanaka left the palace grounds and was never seen again. Finally the Queen decided to become an ascetic too, and remained in the mango grove near the palace, where the sleeping Prince Mahajanaka was first found.

TOP LEFT:
KEVATTA LUNGED AFTER THE JEWEL MAHOSADHA DROPPED, new

BOTTOM LEFT:
BHURIDATTA IS REUNITED WITH SUDSSANA AND HIS SISTER, new

TOP RIGHT:
CANDAKUMARA'S FAMILY IS ABOUT TO BE SACRIFICED, new

BOTTOM RIGHT:
NEMI IS TAKEN BY MATALI THROUGH THE HEAVENS AND HELLS.

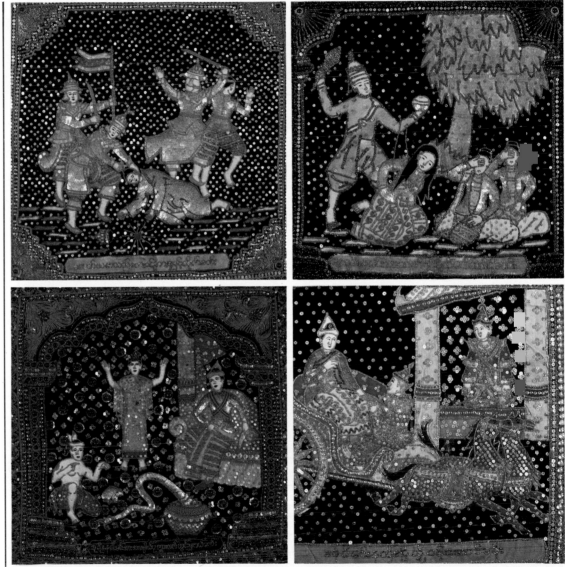

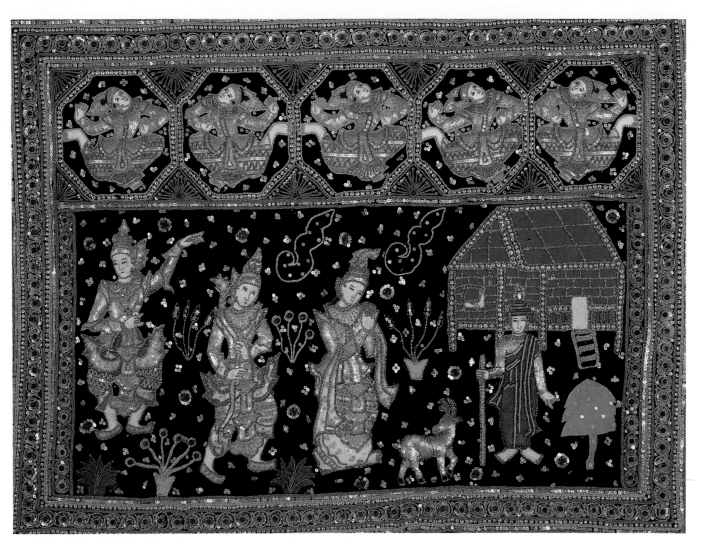

SAMA, THE DEVOTED SON, new

3. SAMA

Devotion

In the kingdom of Benares lived Dukulaka the son of a village chief and Parika, the daughter of another village chief. These two were betrothed to one another as very young children. As they became of age, it was to the great joy of the two villages, that these two should be joined in marriage. Not wishing to upset their parents and the villagers, the couple obeyed, and were married. But neither one wished to live the life of a married couple, preferring to live as brother and sister ascetics in the forest. They set up their home in great simplicity in the forest and lived by eating fruits and berries that they could pick.

As the years went by, and they got older, Sakka, the king of gods became very worried about them. There would be no one to care for them in their old age, so he decided to send them a son. A gentle son named Sama was born to them and he lived as a young ascetic with his parents, with animals of the forest as his companions. He was so gentle that the shy deer flocked to him and accompanied him wherever he went.

When he was sixteen years old, misfortune befell his parents. An evil snake came upon their dwelling, saw the two old people meditating, and blinded them with his evil breath. Sama realized now how much he was needed by his parents and tended to their every need. One day, as he went to fetch water with the deer, the King of Benares, who was hunting saw him and believed him to be a mythical creature, for is it not only mythical or evil beings who can tame deer? The King took out his bow and arrow and shot Sama. The boy fell to the ground and cried out:

"Who did the cruel act to me?"

The King realized his fatal mistake and rushed to Sama's side, asking the boy's forgiveness and explaining that he believed him to be an evil being. Sama forgave the King, but made him promise that he would look after his unfortunate parents in his stead. To this the King agreed and hastened to find Sama's family. When they were told of this tragedy, they asked only to be taken to their son's body. The party of three made their way through the forest to the spot where Sama lay, and as the gods in heaven witnessed this sorrowful sight, they took pity on the family, and restored Sama to life. The King watched the scene in amazement and left the family to return to their huts on their own.

4. NEMI

Resolution

Once there lived a King named Makhadeva who ruled over a kingdom called Mitali in Vedeha. When he noticed his first gray hair, he instructed his barber to remove it. He believed it to be a message from the gods that his youth was over and that it was now time to give up the royal life and become an ascetic, leaving the throne for his son. Each successive generation followed the wise King's tradition until there had been 84,000 kings less two. King Makhadeva who had risen to Brahma's heaven, decided to return to earth and round off the generations. This is how the Boddhisatva was born as Prince Nemi-Kumara, or Prince Hoop. When his father found his first gray hair, Prince Nemi took his place as King. He was a wise ruler, took care of the poor and needy, gave alms, and observed the holy days. He was an inspiration to his subjects, and showed them the right path to follow with his own shining example.

One day, as King Nemi reflected on the mysteries of life, a thought lingered in his mind:

"Was it better to lead the life of an ascetic or merely continue to lead the life of a virtuous King?"

Sakka, from his heaven, heard this question, and in a flash of lightning, descended to assure King Nemi that it was important to do both although leading a holy life was more important. The gods in Tavatimsa heaven heard of this wise and noble King and wished him to visit them. They sent their chariot, drawn by throughbred horses to fetch him on the festival of the full moon. Matali, the charioteer called King Nemi asking him to join him in the chariot, so that they could visit Sakka in his heaven. King Nemi mounted the golden vehicle, but asked to first be taken to visit the hells before climbing into heaven.

The chariot descended into darkness, and after a long time, fire blazed everywhere, and the river Vetarani burned filling the air with terrible smells. Looking closer, King Nemi noticed that it was full of suffering sinners. The King wept to see all of this suffering, and asked Matali what these men had done to be condemned to such pain and torture? Matali explained that they had been terrible sinners in their lifetimes, and made the river disappear. But they continued to descend to the next hell, where humans who had been selfish with ascetics and Brahmins had their flesh torn from their bones by horrible black dogs, vultures and black crows. In another hell, liars and debtors struggled to climb out of a fiery pit. Animal haters had their heads pushed into barrels of boiling water. Matali showed King Nemi all of the hells, as the King wept for the poor sinners.

Sakka and the other gods began to worry about King Nemi and his voyage to the hells, and sent a messenger to Matali to bring Nemi to heaven quickly. The chariot flew through the air, leaving hell far behind. King Nemi looked at the people who had led good lives, many of whom he recognized as his subjects, leading happy lives in beautiful mansions filled with music, beauty and gems. The chariot continued through the many levels of heaven, as Matali explained what the people had done to deserve such rewards. But it was taking so long and the gods were impatient, so they sent another messenger and asked Matali to show King Nemi all of the heavens at once.

King Nemi was still in a state of great amazement when he arrived at the gates of Tavatimsa, the heaven of the thirty three gods, ruled by Sakka. It is a heaven of gods and men alike. The dieties gathered around Nemi, and Sakka asked him to

sit on his throne and enjoy a quiet respite in heaven. But rather than waste his time on enjoyments, Nemi wished to discuss moral precepts. For seven days, he stayed in heaven, speaking with gods, and charming them with his wise and beautiful words. At the end of this time, Nemi declined Sakka's invitation to stay longer, anxious to return to his subjects.

The golden chariot was prepared and Matali led the horses back to his kingdom. As they neared the palace, all of his subjects saw them coming and rejoiced that their beloved King returned to them. He told them of the horrible sights he saw in the hells and of the beauty he saw in the heavens. Each day Nemi reminded his subjects about the importance of doing good and urged them to make the best of their lives on earth.

Many years passed, and Nemi discovered his first gray hair. So in keeping the tradition of his ancestors, he gave up his throne to his son and led the life of an ascetic. At his death, he surpassed Tavatimsa heaven and entered Brahma's heaven of wisdom. This is how King Nemi, the Boddhisatva, rounded off the line of King Makhadeva. At the death of his son, the cycle of the 84,000 generations was ended.

NEMI IS TAKEN BY MATALI THROUGH THE HEAVENS AND HELLS.

5. MAHOSADHA

Wisdom

In the kingdom of Mithila, there once lived a King called Vedeha, who had four clever sages. One night he dreamt that a fifth sage was about to be born and that this sage would far surpass any of the others in his wisdom. On that very day, a Bodhisattva was conceived in the womb of Lady Sumana, a rich merchant's wife in the town. Hundreds of other gods' sons were conceived at the same time so that the Bodhisattva would be well attended. Nine months later, a golden child was born clasping a herb so as to ensure his mother's ease at his birth.

The child grew and became more and more wise. He built wonderful palaces with great gardens and lakes. He gave his advice freely to anyone who came to see him. At this time, the King remembered his dream and sent for Mahosadha. The four sages were sent to fetch him, but they remembered the prophetic dream of their king, and feared that they would lose their positions, so they took their time to find Mahosadha. When they found him, they tried to outwit him, relentlessly throwing riddles at him, but Mahosadha calmly answered each one. Realizing that they could not beat him, they allowed him to enter the court. He gave wise counsel to the king for many years.

One day, a hundred and one kings of India were united under the wicked sage, Kevatta, who plotted to conquer all of India. But Mahosadha knew this was coming and planned well, sending spies to Kevatta's camp, to keep abreast of any challenge Kevatta may put before him. The large army of Kings conquered almost all of India, and only the kingdom of Mithila remained. The army approached the city, and Mahosadha planned a great festival, totally confusing the enemy. Instead of attacking as planned, they regrouped and decided to cut off the city's water supply. Mahosadha had huge fountains built so that the water flowed out of city almost like a flood. The kings believed that Mitali must have deep and full wells, so they planned to lay siege to the city not allowing food to enter the walls. But Mahosadha had prepared great stores of food, and simply dropped food over the walls to feed the enemy army.

The kings were completely taken aback, but tried once again to force the city to surrender. This time, they refused to allow fuel to enter the gates, but Mahosadha merely built fires around the walls demonstrating a large supply of fuel. Again and again Mahosadha cleverly dealt with the tactics of his foes. In one final effort, Kevatta asked Mahosadha to meet him outside the walls of the city, and planned to have Mahosadha bow to him, as he was the younger of the two. As protocol would require, Mahosadha would have to bow first, Mahosadha knew Kevatta would try to trick him, and learned from his spies that Kevatta was extremely greedy. Mahosadha took a large gem with him and walked toward Kevatta. He pulled the jewel from his pocket, allowing it to shine in the bright sunlight. Just as he was within a few feet of Kevatta, he dropped the gem, and Kevatta dived after it. Mahosadha pinned Kevatta down with his foot, saying in a loud voice, so all could hear:

"Come, Kevatta please get up, I am so much younger than you, it is not necessary for you to show your respect to me".

The kings were frightened to hear that the wicked sage succumbed to Mahosadha and fled in panic. But Kevatta would not give up, so he retreated to King Culani's palace and began plotting once again to overthrow Mahosadha. He planned to

marry King Culani's daughter, a beautiful young woman, to King Vedeha and sent him a portrait of the lovely princess, with verses describing her beauty. The poor King never stood a chance. He fell madly in love with the Princess and agreed to marry her. Mahosadha tried to convince the King that it was all an evil plot, but the King would not listen. So Mahosadha left to make the preparation for the wedding at King Culani's palace. He did not have time to lose, and quickly built a palace for King Vedeha outside the palace walls and filled it with riches and

NAT ON PENSARUPA. new, from the Gods of the Planets.

beautiful furnishings. He built a tunnel underground and filled it with lamps, paintings, tapestries, and statues of beautiful women. This tunnel of treasures led all the way to the mouth of the river Ganges where the beautiful Princess lived.

Now all was ready for the arrival of King Vedeha. As soon as the King arrived, he saw the truth and feared for his life. Ashamed that he did not heed Mahosadha's warning, he asked the four sages to help him find a way to escape. Each one sadly shook his head, unable to aid their King. At long last, King Vedeha asked Mahosadha to please help, but Mahosadha pretended to be helpless until he felt that the King realized his foolishness. At last, Mahosadha revealed the tunnel to the King and led him and his court to freedom. In the meantime, Mahosadha sent soldiers to find the Princess and to describe the beautiful tunnel, enticing her to enter it. Then they led her and her women through the tunnel to the cave where King Vedeha

waited for her. At first she was afraid, but was soon reconciled to her demise. The Princess and King were married, and quickly left to return to their kingdom of Mithila.

Mahosadha waited for King Culani to hear of the disappearance of his daughter and King Vedeha. The distraught King rushed through his palace, through the tunnel and found Mahosadha in the cave brandishing a sword. Mahosadha lept into the air shouting:

"To whom do the kingdoms of India belong?"

King Culani shook with fear and dared not answer or even look at the sage. But Mahosadha wished him no harm and put the sword down. He asked the King to swear friendship to the kingdom of Mithali and all the other kingdoms of India. King Culani did this and also swore to banish Kevatta, the evil sage from his kingdom. This is how Mahosadha, the Bodhisattva, brought peace and happiness to the kingdoms of India.

6. BHURIDATTA

Moral Practice

Deep beneath the sea, in the bowels of the earth, there is a kingdom that belongs to the Nagas, or mythical serpents bestowed with magical powers that allow them to assume human form and visit our earth. It is a beautiful kingdom filled with riches and magnificent jewels.

The Garuda, a mighty bird, is the mortal enemy of the Naga. One day, long ago, a garuda was flying in the sky, saw a naga and snatched it up, overpowering it and eating it with great relish. But when the garuda finished his meal, he was overcome with feelings of guilt and remorse. He found an ascetic in the forest and asked what he should do so as not to suffer from this ignoble act. The ascetic assured him that he would suffer no longer, and the grateful garuda gave the ascetic a snake charming spell. The hermit had no use for it and gave it to a Brahmin named Alambayana, a snake charmer.

Alambayana wished to capture a mighty naga and gain fame and fortune, as none had ever been caught. One day, he reached the banks of the Yamuna River where a group of naga boys were guarding their precious gem that granted all wishes. The snake charmer uttered the spell and the fearful nagas returned to the waters without the gem. Alambayana seized it, not realizing it's value and continued on his way. He met a woodcutter who recognized it as a special gem, and promised the snake charmer that he would help him capture a naga, if he could have the gem as payment for his services. The men agreed and set off to capture a naga.

The woodcutter knew Prince Bhuridatta, a naga prince who liked to meditate coiled around an anthill. Some years earlier, the Prince asked the woodcutter and his son not to divulge his hiding place and took them both to the realm of nagas for a year of luxury. When they returned, they resumed their lives as woodcutters in the forest. The woodcutter's son heard what his father was planning and urged him not to give away the secret hiding place of Prince Bhuridatta, but the old woodcutter's greed surpassed his reason and he led Alambayana to the anthill.

The snake charmer uttered the magic spell and seized Prince Bhuridatta, crushing his bones and forcing him into a sack. The gem granting all wishes was given to the wood-

cutter, who dropped it and watched as it fell through a crack in the earth into the realm of nagas. Alambayana forced Bhuridatta to perform in market places as a common snake. The Prince performed inspite of great pain from his wounds and danced so wonderfully that it brought the snake charmer lots of money. They moved from city to city, and as time passed, they came to Benares. Bhuridatta's brother, Sudssana, had assumed the dress of an ascetic in order to look for him. His sister had disguised herself as a frog and sat on Sudssana's shoulder. They recognized each other, and Bhuridatta put his head on his brother's leg and cried. Alambayana thought that Bhuridatta had bitten the ascetic, but Sudssana boasted that no venom could harm him.

Alambayana was angered by Sudssana's audacity and challenged him to show his powers. The frog jumped off Sudsanna's shoulder to spit three drops of venom into his hand. Sudsanna announced that if he poured these three drops of poison on the ground, the whole city of Benares would blow up. In order to prove his words, he dropped a tiny bit, enough to create a small explosion. The crowd shrank back

in fear and sent for the King. Calmly, the King asked how the poison could be destroyed without harming the city and its inhabitants and what the ascetic wanted. Sudssana requested only that his brother be set free, and the King agreed.

Three huge pits were dug. In the first, drugs were placed, in the second, cow dung was shoveled, and in the third, medicines of all sorts were piled in. Then the three drops of poison, one drop at a time, were poured into the pits. An explosion of great force rocked Benares, and a noise like thunder rang in the skies; but after the smoke had cleared, no one had been hurt, and no buildings had been damaged.

The evil snake charmer, Alambayana, vowed three times that he would set the Naga Prince free. With this, the snake charming spell was broken, and the Prince emerged from the basket in full regalia. The two brothers and sister presented themselves to the King, who also happened to be their uncle. A great celebration was held in the city and soon thereafter, they returned to the Kingdom of Nagas. The evil Alambayana stole away during the festivities and was never heard of again.

7. CANDA-KUMARA

Forbearance

Near Benares, there was the kingdom called Pupphiavati, where King Ekaraja reigned. The King's son, the much beloved Canda-Kumara, served the King and the people to the best of his ability. Also in the employ of the King was an evil Brahmin, named Khandahala, who the King trusted implicitly. Khandahala was a jealous man and plotted to destroy Prince Canda, although he knew that the Prince was a Bodhissatva.

Khandahala was a judge in the kingdom and often ruled unwisely and without compassion. In one instance, Prince Canda was forced to intervene and reverse a judgement. This made him all the more popular with people, and he was beseeched again and again to intervene on their behalf. This infuriated Kandahala, but when the King made his son a judge also, there was no calming the irate Kandahala.

One night, the King dreamt of heaven and all of its beauty, inhabited by devas and other deities. He was so enthralled by these sights that he quickly called Kandahala to ask him if he could attain a life in these realms. Kandahala saw that this was his chance to get rid of Prince Canda, and suggested that the only way the King would reach heaven, was to give away all of his worldly riches. He would have to sacrifice animals and humans, preferable members of his family, in fours. The King was so fervent in his desire to reach heaven that he would not listen to the reason of his son or family. As the King made preparations for the great sacrifice, sadness fell over the kingdom.

No one could understand what had befallen their ruler. Everyone knew that it was the evil Kandahala's doing, and that perhaps their ruler had gone mad. The time came for the bloody sacrifice, and Prince Canda's wife called to the gods to witness what was about to happen. She reminded them that everything humanly possible had been done to try and prevent this horrible massacre. Sakka heard the Princess's prayer and descended to earth in a flash of lightning, knocking over the royal umbrellas, so that all present would realize that this ceremony was not holy. In a circle of fire, he appeared to the crowds.

The subjects of Pupphiavati waited for just such a signal, and jumped on Kandahala, clubbing him to death. Sakka saved the foolish King, by leading him to the forest, where he would spend the rest of his life as an ascetic and prepare his path to heaven in the right manner. The people rejoiced and crowned Prince Canda as their king. His reign was a peaceful and prosperous one, but he never neglected his father and made sure that all of his needs were taken care of.

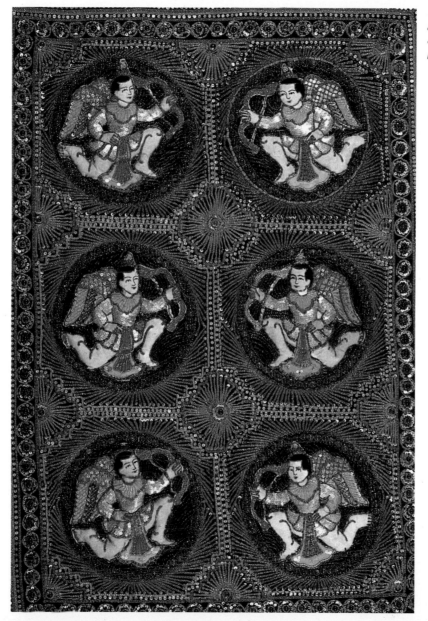

CUPIDS, new. The wings
are not at all Asian,
although the kneeling
pose is often seen.

8. NARADA

Equanimity

In the Kingdom of Vedeha, King Angati lived with his beautiful daughter, Ruja. She was his greatest joy, and he lavished all of his wealth on her. King Angati was a good king, and each month, he gave alms to the poor and needy and took great care of his subjects. One month before the festival of the full moon, the King's courtiers decided to seek out an ascetic who lived the forest to ask him about the mysteries of life.

The King and his court found Guna the ascetic after two days of travel. They approached him and asked him to explain why some men reap the rewards of heaven while others suffer in hell. Guna wasn't a very good man and didn't know the answers. He believed in half-truths, so he simply replied:

"No matter what you do, your life is predestined, the outcome will always remain the same. If you are destined to be born in·hell, or in heaven, nothing that you do, good or bad, can change that".

Alata, one of the King's generals, retorted:

"Hah! I knew it all along. I was never punished for being a hunter in my last life".

A slave in rags added:

"I have only led a pure and virtuous life, and still I was born a slave".

These stories influenced King Angati to give up all of his good deeds, and to lead a life in which he cared only for his creature comforts. Ruja did not believe that her father could continue in this manner for long, and asked him for the gold to be given as monthly alms. But he refused to give her any gold or listen to her pleading. She warned him that if he did not resume a viturous life, he would suffer in hell for his misdeeds. Nothing could sway the·King, and finally Ruja fell to her knees and begged the gods in Brahma's heaven to send a sign that would rid her father of his foolish ideas.

Narada, the Boddhisatva, heard Ruja and decided to help. He disguised himself as an ascetic and descended to the earth. Ruja recognized him as the heavenly messenger, and prostrated herself in front of him. The king was shocked to see his daughter bowing to this unknown ascetic and shouted:

"Who are you, where do you come from?"

Narada replied:

"I am the Great Brahma from the Brahma heavens, and I have come to the earth to tell you that if you continue to lead such a miserable life, you will be condemned to hell".

The King only taunted Narada saying:

"If what you say is true, lend me five hundred pieces of gold, and I will repay you one thousand if I end up in hell".

To this Narada replied:

"If you were virtuous, I would lend you the money because I am sure to collect from a man in heaven. But a man like you who chooses to follow the wrong teachings will be condemned to one of the thousands of hells, and no one would wish to collect a debt in such a place".

The King refused to listen, so Narada told him of the terrible suffering that would befall him in the hells that awaited him. He told him of the hells where animals gnaw one's body, where fire burns day and night as one tries to escape, where everything in nature relentlessly tortures the body. The King finally became afraid and asked Narada to help him. Narada told him that the time had come for him to resume the responsibilities of the kingdom, and provide for the poor and needy, the aged and the Brahmins. He told the King to follow his daughter's good example, allowing the mind rather than carnal desires to be his

guide to find the right path to heaven. Both the father and daughter bowed to the Great Brahma and gave thanks, as the Great Brahma returned to his heaven.

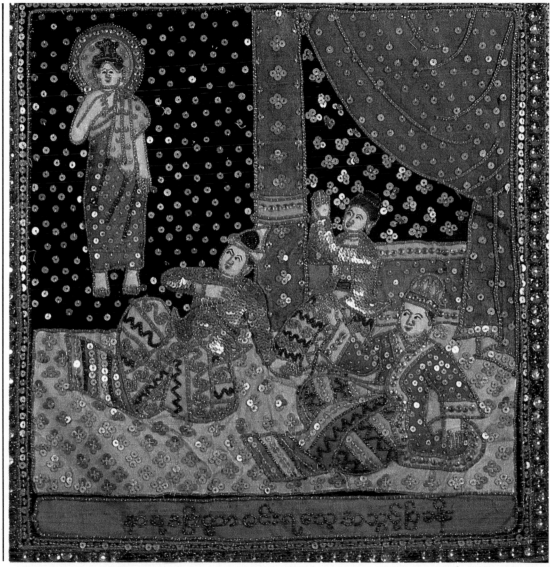

NARADA APPEARS BEFORE KING ANGATI AND HIS DAUGHTER, new

9. VIDHURA-PANDITA

Truth

Thousands of years ago, in the kingdom of Indrapatta, there lived a wise sage named Vidhura-pandita, who served King Dhananjaya. He was known throughout the land, and his voice was heard everywhere. One day, the Queen of Nagas wished to hear him speak and to have her husband listen to his wise counsel, so she pretended to be very ill and cried to her husband that the only cure for her illness would be the heart of Vidhura-pandita. The distraught King of Nagas thought that his Queen was asking too much of him to commit such an ignoble deed, but to save her, he succumbed and sent his daughter Irandata to find a husband, who would kill Vidhurapandita for them.

The princess took off for the Himavat Forest and surrounded herself with plants and flowers. She burst into song, singing enchantingly for someone to come and marry her that very evening. A yaksa named Punnaka heard her song and rushed to her side. Together they rode to the Naga palace and asked to be married. However, the King would only agree if Punnaka delivered the heart of Vidhura-pandita to him.

Punnaka agreed, and is sure that with his magical powers, he would be able to capture Vidhura-Pandita and marry the Princess.

Dressed in all of his finery, Punnaka entered the palace of King Dhanajaya. He enchanted the King with his magic and proposed a game of dice. If the King won, he would take possession of Punnaka's magic stone and horse. If the King lost, everything except the King's white umbrella would go to Punnaka. The game was set up on a platform, and Punnaka took the lead. The King was baffled, as he had always had a guardian goddess who helped him win in the past. But her magical powers could not match those of Punnaka. With three throws of the dice, Punnaka won, and quickly asked only for Vidhura-pandita as his payment. The King was shocked, but he conceded. Punnaka shouted at Vidhura-pandita and told him to ready himself. Vidhura asked Punnaka to give him three days in which to say goodbye to his family and friends. Punnaka agreed, and in the next three days, Vidhura preached to the court about the path they must follow in their lives. Everyone wept as Vidhura was whisked off by Punnaka.

Clutching onto the horse's

tail, Vidhura listened to Punnaka tell him that he would never see the world of men again. He was not afraid, and Punnaka tried to frighten Vidhura to death in many ways, to no avail. Punnaka realized that he would have to kill Vidhura with his own hands and grabbed him by the throat to string him upside down, but Vidhura remained calm and asked why Punnaka had to kill him. Punnaka explained that the Naga Queen requested the heart of Vidhura, and Vidhura realized that it is not his physical heart that she wanted but his teachings and wisdom. He explained this to Punnaka, who realized his error and released the poor sage. But rather than return to his kingdom, Vidhura travelled with Punnaka to the realm of Nagas, to visit the Naga Queen.

They entered the palace, and Vidhura spoke to the King, Queen, Princess and Punnaka, and when he had given all of his teachings, he said that he did not care if he must die. The Naga King was a wise man and realized that his wife had requested the heart of the sage, which had just been given to them in the form of his teachings. So the King allowed Vidhura-pandita to return home and gave his daughter in marriage to Punnaka, for indeed, Punnaka had delivered the heart of the sage. Punnaka made a solemn vow to follow the right path for the rest of his life.

NAT ON SINGHA. new, from the Gods of the Planets.

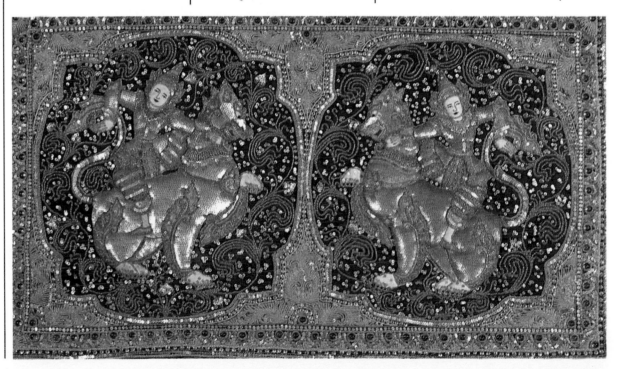

10. VESSANTARA

Charity

Introduction

This, the tenth jataka tale, is also known as the Mahachat or the Great Birth. It is perhaps the most popular of the jatakas, and is featured in many kalagas and temple murals. Once a year, this jataka is recited, and it is the one tale most Burmese and Thais are able to recount with accuracy. It is a beautiful story of a charitable prince who gives up everything to achieve omniscience.

Long ago, in the kingdom of Sivi, King Sanjaya reigned wisely and with great compassion. His Queen Phusati, Sakka's consort, had descended from heaven to give birth to the Boddhisatva, in his last birth before becoming the Buddha.

When Vessantara was born, he showed greatness while still in the cradle. He gave away every ornament from his own bed to those in more need than he. During his childhood, he often wished to give something of great value away, something of his very own, that had not been given to him. He would have liked to give away his heart, eyes, legs or any other limb if someone asked. The gods took notice of this Great Being, and thunder roared in the skies.

At sixteen, Vessantara had completed his studies, and was promised in marriage to Princess Maddi, from a neighboring kingdom. In a lovely ceremony, the two were joined, and they had a happy marriage. They were blessed with two beautiful children, Jali, a son, and Kanhajina, a daughter. Soon King Sanjaya gave up his throne to his son, and the kingdom prospered.

A white elephant had grown up with Vessantara, and as a young prince, he rode the elephant in ceremonies to give alms. A white elephant is very lucky, and it is believed that they bring rainfall and plentiful harvests. The neighboring kingdom of Kalinga suffered from a terrible drought, so seven Brahmins were sent to ask Vessantara for his white elephant. Willingly, Vessantara gave the Brahmins his white elephant by pouring lustral water over their hands, as is the tradition, when a gift given is too large to hand someone.

All of his subjects were distraught when they learned that Vessantara had given the white elephant away, so they urged King Sanjaya to resume the throne and banish Vessantara from the kingdom. On the next day, Vessantara disposed of all of his wealth, which is known as the gift of the seven hundred. He gave away seven hundred of each type of animal or object he owned. People came from all over to receive a gift.

At dawn, the banished Vessantara left the palace with Maddi and his two children in a chariot drawn by four horses. Four Brahmins appeared to ask him for their horses which Vessantara gave willingly. Then a fifth appeared to ask for the chariot. The family continued on foot, Vessantara carrying his son, and Maddi carrying her daughter. They refused the offer made by the King of Ceta to assume the rule of his kingdom and settled in the foothills of the Himalayas at the foot of Mount Vanka.

Sakka built two huts for them, and Vessantara took the vows of an ascetic and lived in one hut. Maddi and the children lived in the other. Maddi continued to take care of her husband, and fed him fruits, nuts and leaves that she was able to collect in the forest. Seven months went by, when an ugly old Brahmin appeared. He was from Kalinga, the new home of the white

elephant, and had heard of Vessantara's generosity. His pretty young wife had no servants to serve her and was the ridicule of the town, so she urged her husband to find her some children to serve her. The Brahmin went into the forest and hid until he saw Maddi leave to collect fruits and berries. He approached Vessantara and explained why he wanted the children. Vessantara called his children to him and gave them to Jujaka, who tied them up with vines and led them away crying. Vessantara was overcome with sorrow and meditated on non-attachment to regain his ascetic calm.

In the meantime, Maddi was in the forest, and the gods sent a lion, tiger and leopard to keep her away from seeing the terrible, sad scene. At nightfall, she returned to the hermitage to find her children missing. All through the night she searched for them and collapsed on the floor in the morning from worry and exhaustion. Vessantara was overcome with pity, and broke his ascetic vows by taking her into his arms to revive her. He then told her that he gave the children away to Jujaka, and she rejoiced with him in his desire to achieve omniscience.

Sakka realized that Vessantara would now make the last and greatest sacrifice of all, by giving Maddi away. In order to save Maddi from a life of misery, he disguised himself as a Brahmin and asked Vessantara for his wife. Maddi submitted in silence and realized that she helped her husband achieve his greatest wish, perfect wisdom. The heavens shook creating an incredible sound, the ocean foamed up roaring waves and the gods acknowledged Vessantara's omniscience. Sakka knew that Vessantara was capable of supreme charity and returned Maddi to him.

Jujaka on the other hand, was lost in the forest with the children tied to a tree trunk, while he slept in the tree. Deities took various forms to nurture and feed the children, and the gods guided Jujaka back to Sivi instead of to Kalinga. When they arrived in Sivi, the children were recognized, and taken to their grandfather, King Sanjaya. He was so relieved to have his grandchildren back that he rewarded Jujaka instead of punishing him, but Jujaka died soon thereafter from an excess of food and grand living to which he was unaccustomed.

The children told their grandfather about their parents and Jali reproached him for allowing

his father to be banished. The King decided to fetch Vessantara and Maddi and set off with a royal procession. As they neared the hermitage, Vessantara and Maddi were frightened by the sounds, so they climbed a hill for a better look. Instantly Maddi recognized the banners of Sivi and assured Vessantara that they had come to take them back to Sivi. King Sanjaya approached them alone at first, to assure himself that they were all right. Then he called to Phusati, Jali and Kanhajina to join him. The earth trembled, lightning streaked the sky and a rain of heavenly silver showered the royal family as the gods blessed them. King Sanjaya asked Vessantara to resume his role as the King of Sivi.

Before Vessantara left his hermitage, he circled his hut three times saying:

"Here I have attained omniscience".

And prostrated himself three times before it. He and Maddi were bathed, dressed in royal attire, and returned to the royal camp. After a month of festivities in the forest, they returned to Sivi in a royal procession of great pomp.

King Vessantara had a long reign of glory, and the kingdom of Sivi prospered. When he passed away, he ascended into Brahma's heaven. His life has become a perfect example of charity and benevolence for all time.

THE GIFT OF THE WHITE ELEPHANT, new

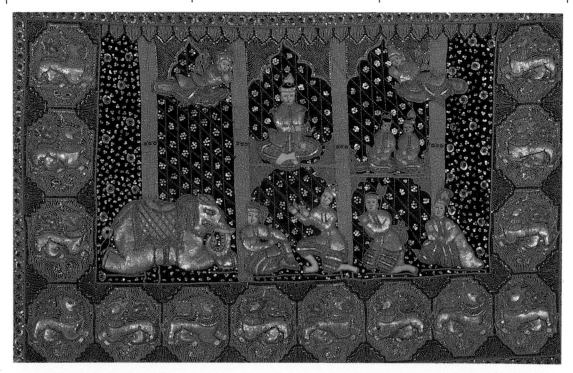

THE LIFE OF PRINCE SIDDHARTHA

I have written an account of the life of Prince Siddhartha until the time that he leaves the palace to become an ascetic. Since the traditional theme of the Kalaga does not depict the more religious time of Prince Siddhartha's life, when he sought enlightenment, found it, and became the Buddha, I have not included it in the text.

On the full moon day of the sixth lunar month, in the eightieth year before the Buddhist era, a son was born to King Suddhodana and Queen Mahamaya, who the Brahmins named Siddhartha. No sooner was the Prince born from his mother's womb, did he perform the miracle of walking seven steps. It was the first omen to the greatness of this being.

The famous sage, Asita, visited the King when he heard of the birth of this great being. His wish to see the Prince was so great that the Prince appeared on the head of the sage. Everyone was astonished to see the baby Prince on the head of an elderly and wise sage. This miracle proved that the Prince was the Boddhisatva, and everyone bowed to him.

At the same time, eight Brahmins went to visit the King, and one of them foretold that the Prince would either become a great emperor, or if he were ordained a monk, he would attain Enlightenment and become the Buddha.

When the Prince was seven years old, he attended a ploughing ceremony with his father. The little Prince sat in the shade of a rose apple tree waiting for the ceremony to come to an end and was so relaxed that he fell into a deep trance. When the royal attendants returned to find the Prince, the sun was already casting long shadows, but the shadow of the rose apple tree remained directly above the Prince, as if it were still high noon. The attendants informed the King who interpreted this phenomenon as a sign of the great destiny that lay before his son and raised his hands in salutation.

According to royal tradition, Prince Siddharta studied the art of archery and became very proficient. He was able to beat every opponent, including Devadatta, his rival. It was important for the Buddha to excell in all things, which he showed in a contest he won.

Prince Siddhartha was betrothed to Princess Yasodhara, and they were married in a beautiful ceremony. They lived in the palace and soon a son was born to them. Just before Prince Siddhartha's thirtieth birthday, he left the palace grounds for a ride in his chariot. This was his first venture beyond the walls of the palace. During this ride he encountered four heavenly messengers: an old man, a sick man, a dead man, and finally a monk. He was so saddened by the plight of human suffering that he realized he must give up his princely life and become an ascetic. He returned to the palace to see his wife and son, who he named Rahula. Looking around them he saw the courtiers asleep and thought how much like animals they seemed. That very night, he summoned his trusted servant, Channa, to saddle his horse Kanthaka, and he rode out of the palace gates, with Channa grasping onto the horse's tail as they rode into the night. A deity led the way, with Sakka following behind. Other deities helped the horse's hooves to fly through the sky.

Mara the demon tried to stop Prince Siddhartha's departure, but the Prince brushed him aside and continued on his way. In the early morning, he arrived at the bank of the river Neranjara. He took off his clothes and gave them back to Channa to return to the palace with a farewell note to his family. Channa, and even the horse, cried. Prince Siddhartha remained strong. A group of devas gathered, and Sakka paid homage, giving Siddhartha the robes he would need as a monk. Siddhartha then took his sword and cut off his hair to become an ascetic.

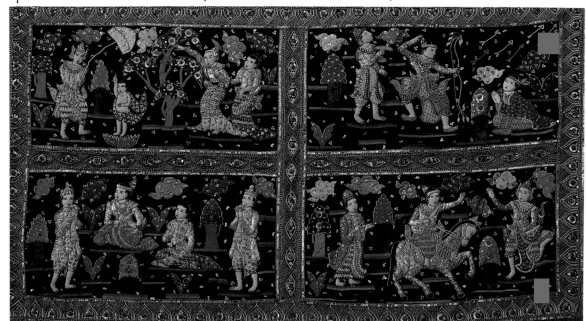

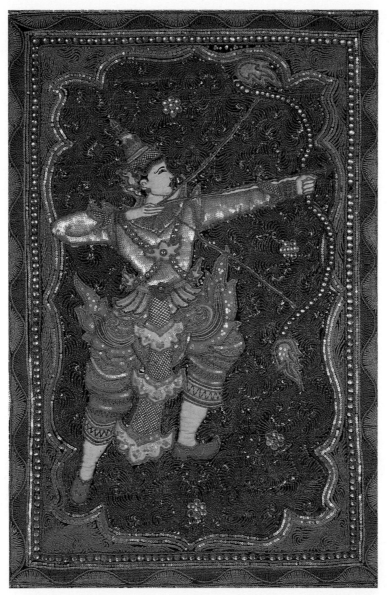

PRINCE SIDDHARTHA
WITH BOW
AND ARROW, *new*

THE GODS OF
THE PLANETS

In early Hindu astrology, nine planets were recognized, they were: The Sun, Moon, Mars, Mercury, Rahu, Jupiter, Venus, Saturn, and Kate.

The Burmese have accepted this astrology more readily than the Thais, but some evidence remains in Thailand that this type of astrology was followed. In the Burmese temples, each day, which is ruled by a planet, has a corner set up for those born on that day to worship. Each day has an animal, and in the themes of the kalagas, deities are often shown riding the animal.

These gods of the planets are often used in religious ceremonies to bring good luck to a household. In Burmese astrology, the day of birth is a very important factor in the formation of one's character.

You will notice that there are nine planets, but only seven days. Wednesday is split into two days, and the eight planet, Kate is the king of all. The animal sign of this planet is the PEN-SARUPA, a mythical creature with the antlers of a deer, the tusks and trunk of an elephant, the mane of a lion, the body of a naga, and the tail of a fish.

I have made a chart to show how the planets are placed. If you were to visit a Burmese temple, you would have no trouble finding your corner to offer prayer, if you know the day on which you were born.

Northeast Sunday Sun Galon	East Monday Moon Tiger	Southeast Tuesday Mars Lion
North Friday Venus Guinea Pig (Ox)	Kate Pensarupa	South Wednesday (Day) Mercury Elephant/Tusks
Northwest Wednesday (Night) Rahu Elephant	West Thursday Jupiter Rat	Southwest Saturday Saturn Naga

THE ANIMALS OF THE BUDDHIST YEARS

If you have ever visited Thailand or Burma, you would have noticed how important it is to have your horoscope read. When any special event needs to be planned, you can't plan it without a visit to an astrologer. Businessmen who come to Thailand on a foreign posting are usually surprised that something as simple as moving the office requires a visit to the astrologer for an auspicious day. Then Buddhist monks are asked to come in the early morning and give their blessing for the business to be successful. A ceremony is held. The monks chant and bless a thin white string that is strung all the way around the office or building, and everyone joins in giving useful gifts to the monks. This same ceremony is held when moving to a new house. A young couple planning to get married would never choose the day themselves. Usually they would consult the astrologer together.

Almost every child in Southeast Asia knows his day of birth, date of birth, year of birth, and probably has an astrology card which would have been set up for him by an astrologer soon after his birth. In our family, we have always known on which days we were born, which animal year, and have often consulted the hundred year calendar to find this information for friends. We even have a resident numerologist, Nai Rian, who translates all of this information into numbers to give readings. He is able to help us select auspicious days for us to move, take trips, begin businesses, and yes, even write books! He enjoys quite a bit of success with clients he has helped for years. Very often the family astrologer is a Buddhist monk, but he might be a business man or from almost any walk of life. They are usually well respected and often do not charge for their services, leaving it up to each person to donate some cash for the reading which is sometimes donated to a temple for a worthy cause.

Now let me tell you a little about the twelve year cycle, and then you can find your animal year by looking up your occidental birth year in the chart

One New Year's Day long ago, the Buddha called all the animals of the forest to come and pay homage to him. But only twelve came, and a year was named for each of them.

Every twelve years, the cycle starts again, beginning with the year of the rat and ending with the year of the boar. As one ages in Thailand, each cycle birthday becomes very important. A fifth cycle or 60th birthday, a sixth cycle or 72nd birthday, a seventh cycle or 84th birthday are all very important ones. Usually the immediate family and all of the children will visit the older relative to pay their respects, as they do on every New Year's Day.

Most Thais are happy to tell you their age, but you will need to phrase the question correctly, you always ask:

"What year were you born?"

Fully expect to be given an animal year, and then you decide which cycle this person is in.

Each year takes some characteristics of the animal for which it was named. You will also notice that the people born in that year will take some of the characteristics of that animal as well. I have known people born in the year of the rat to be hoarders, people born in the year of the ox to be hard workers tiring long after everyone else has thrown in the towel, and people born in the year of the dragon to be very powerful and strong willed. If you wonder why you fare better in some years, and miserably in others, you may need to read one of the many interesting books on this subject.

In Thailand, the year began on the Thai Lunar New Year, Songkran but some years back, the government changed the beginning of the year to coincide with the beginning of the Roman year. Most astrologers still use the ancient system, with the year beginning on Songkran Day in April. If you were born between January and April, and feel that you don't fit in the category of your year, look to the earlier one.

The animals came in the following order:								
The Rat								
1900	1912	1924	1936	1948	1960	1972	1984	1996
The Ox								
1901	1913	1925	1937	1949	1961	1973	1985	1997
The Tiger								
1902	1914	1926	1938	1950	1962	1974	1986	1998
The Rabbit								
1903	1915	1927	1939	1951	1963	1975	1987	1999
The Naga*								
1904	1916	1928	1940	1952	1964	1976	1988	2000
The Snake								
1905	1917	1929	1941	1953	1965	1977	1989	2001
The Horse								
1906	1918	1930	1942	1954	1966	1978	1990	2002
The Goat								
1907	1919	1931	1943	1955	1967	1979	1991	2003
The Monkey								
1908	1920	1932	1944	1956	1968	1980	1992	2004
The Cock								
1909	1921	1933	1945	1957	1969	1981	1993	2005
The Dog								
1910	1922	1934	1946	1958	1970	1982	1994	2006
The Boar								
1911	1923	1935	1947	1959	1971	1983	1995	2007

*The Naga in Burma and Thailand is also known as the Dragon in China and Japan.

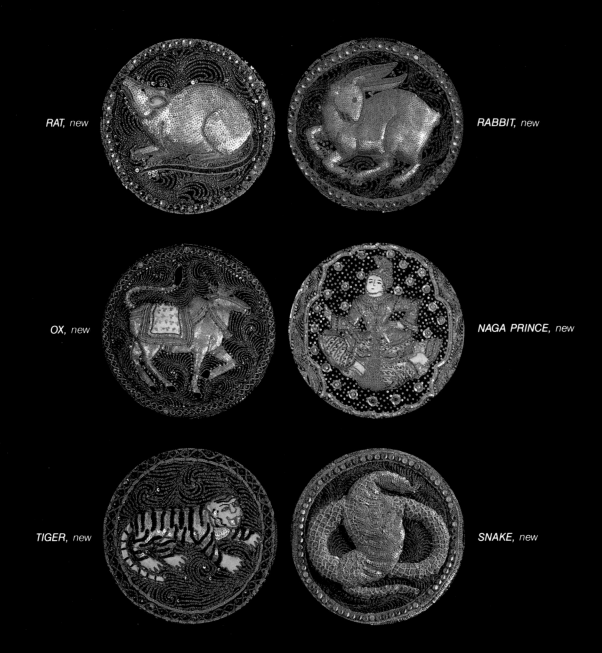

RAT, *new*

RABBIT, *new*

OX, *new*

NAGA PRINCE, *new*

TIGER, *new*

SNAKE, *new*

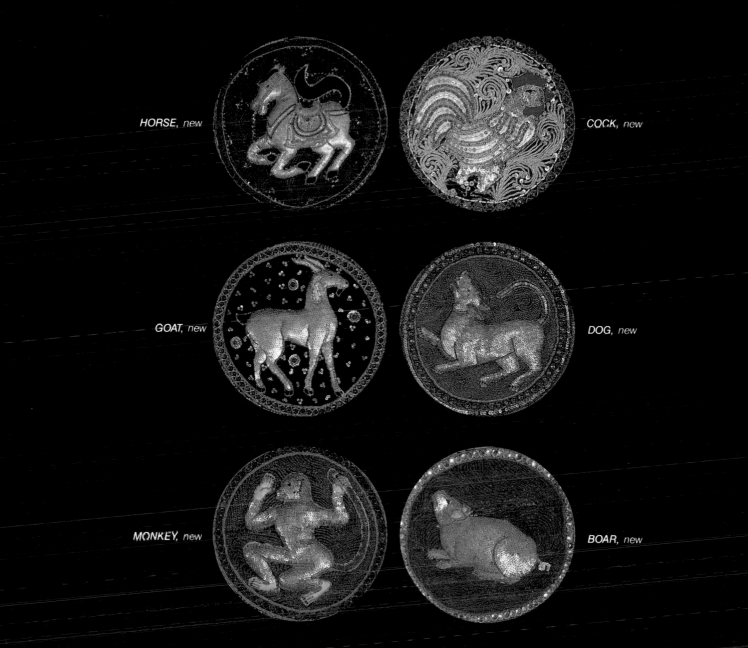

HORSE, *new*

COCK, *new*

GOAT, *new*

DOG, *new*

MONKEY, *new*

BOAR, *new*

43

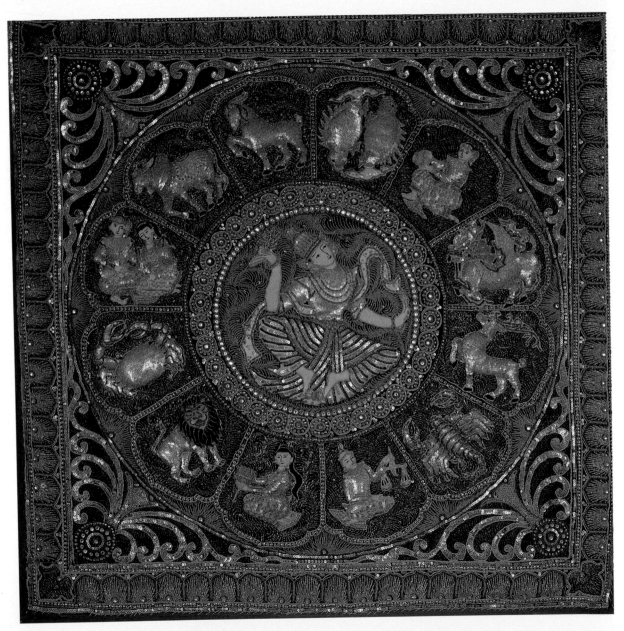

HOROSCOPES

The months of the year in Thai are named for animals, some are real, some are mythical. They closely resemble the horoscopes known in the occidental world. The Burmese animals are very similar to the Thai although the names of the months are quite different.

MONTH	WESTERN NAME	THAI NAME/MONTH	BURMESE NAME/MONTH
APRIL	Aries	Rasee Made/Mesayon	Meiktha/Tagu
MAY	Taurus	Rasee Prug/Pusapakom	Peiktha/Kahson
JUNE	Gemini	Rasee Maytun/Mitunayon	Meidon/Nayon
JULY	Cancer	Rasee Grok/Galakadakom	Karaka/Wazo
AUGUST	Leo	Rasee Singh/Singhakom	Thein/Wagaung
SEPTEMBER	Virgo	Rasee Gan/Ganyayon	Kan/Tawthalin
OCTOBER	Libra	Rasee Tun/Tulakom	Tun/Thadingyut
NOVEMBER	Scorpio	Rasee Pijik/Pisijigayon	Pyeiksa/Tazaungmon
DECEMBER	Sagittarius	Rasee Tanoo/Tanwakom	Danu/Nadaw
JANUARY	Capricorn	Rasee Mankorn/Makarakom	Makara/Pyatho
FEBRUARY	Aquarius	Rasee Goum/Guompapan	Kon/Tabodwe
MARCH	Pisces	Rasee Meen/Meenakom	Mein/Tabaung

**The Mankorn or Makara is a type of sea creature rather than the traditional capricorn goat we seem to find in the occidental signs. However, I have seen the capricorn pictured with the tail of a fish, thus we can assume that these horoscopes do have the same roots.*

What a job the astrologers have in Burma and Thailand. Each day, month, and year has an animal signs. It is no wonder that the 100 year calendar is such a best seller! In addition to all of this, there are even animals for the hours, so in planning any important function, everything must be taken into account.

VI

BURMESE NATS

In Burma and Thailand, it is believed that spirits live in the trees, waters, in fact everywhere in nature. In Thailand, one sees spirit houses in the compound of every home. This is an ancient form of worship that was included into the Buddhist religion. In Burma, one sees shrines along the road and in front of the temples for Nats.

Long before Buddhism spread from India to Burma, the Burmese worhipped nats, the name given to these spirits. This national cult was first given royal support by King Thinlinkyaung of Pagan. All of his successors continued to support this form of worship. During the 4th century B.C., Mount Popa appeared on the Myingyan plains as the result of an earthquake. This mountain, albeit small, was named as the official home of the nats, and each King climbed the golden mount ot pay his respects. Each year, Nat festivals was held on Mount Popa, and have remained a tradition to this day.

When Anawrahta came to the throne in 1057, the first Burmese empire was established. Buddhist monks captured from the Mon capital of Thaton greatly influenced the King and the spread of Buddhism began in Burma. By the time Anawrahta had come to the throne, the Nats had grown in number to thirty-six which were recognized nationally. He found this cult very difficult to suppress, as the people feared that if they stayed away from the Nat shrines, the Nats would be angered and wreak havoc with their lives. Finally Anawrahta had to compromise, so he decided to change the number of spirits to thirty seven, adding Thagyamin (Sakka, the god of Tavatimsa heaven) as the head of the pantheon. In this way, the Nats were shown as supporters of the Buddhist faith.

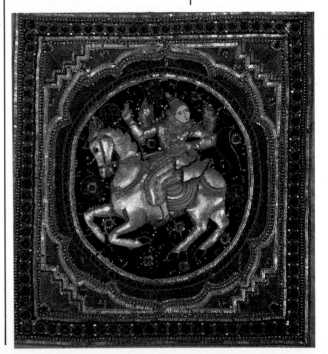

CAPTAIN AUNGSWA BURMESE NAT, new

THE THIRTY SEVEN NATS OR LORDS:

1. Thagyamin (Sakka, the King of Gods)
2. Lord of the Great Mountain
3. Princess Golden Face
4. Lady Golden Sides
5. Lady Three Times Beautiful
6. Little Lady with the Flute
7. Brown Lord of Due South
8. White Lord of the North
9. Lord with the White Umbrella
10. Royal Mother of the Lord of the White Umbrella
11. Sole Lord of Pareim-ma
12. Elder Inferior Gold
13. Younger Inferior Gold
14. Lord Grandfather of Mandalay
15. Lady Bandy Legs
16. Old Man of the Solitary Banyan Tree
17. Lord Sithu
18. Young Lord of the Swing
19. Valiant Lord Kyawswa
20. Captain Aungswa of the Army*
21. The Royal Cadet
22. Lady Golden Words, mother of the Royal Cadet
23. Lord of the Five Elephants
24. Lord King, Master of Justice
25. Muang Po Tu*
26. Queen of the Western Palace
27. Lord Aungpinle, Master of the White Elephant*
28. Lady Bent
29. Golden Nawrahta
30. Valiant Lord Aung Din
31. Young Lord White
32. Lord Novice
33. Tabinshwehti
34. Lady of the North
35. Lord Minhkaung of Toungoo
36. Royal Secretary
37. King of Chiengmai

Each of these Nats has a story, but many of them have been lost or stories have been combined over the years. In most cases, they are people who actually lived but came to a sudden death, some were heros, some were members of royal families and courts, and some were merely commoners.

Three of the Nats seem to be the most popular motifs for kalagas. I have constructed the stories from many different sources and have tried to be as accurate as possible.

Captain Aungswa of the Army

Captain Aungswa is always pictured riding his horse in full regalia. Many kalagas show his horse rearing, as if to gallop off in great speed.

During the reign of King Naratheinkha (1170–1173), Aungswa was a captain in the First Army of the Kingdom. Crown Prince Narapathisithu, brother to the King, was the commander in chief. The King was in love with his brother's wife and plotted to send the Crown Prince and his army to the border, so that he could seduce the Princess and make her his fourth wife. Telling the Crown Prince that a rebellion had broken out, the King gave orders to move the Army out and quash the uprising.

But Prince Narapathisithu suspected foul play, and left a spy behind in the palace. The Army was camped not too far from the palace, on the other bank of a river. Only a few days had gone by when the King forced the lovely Princess to become his fourth wife. With great haste, the spy, Nga Aung Pyi, rode out of the palace to inform the Crown Prince of the tragedy. He rode the Prince's favorite horse to the river but couldn't cross as the moon was full and shone so brightly on the river that it looked much deeper and wider than it actually was. All night, the horse neighed to his master on the other bank, but no one could cross. When daylight broke, Nga Aung Pyi hastened to the Crown Prince and told him what had transpired at the palace.

The Crown Prince quickly dispatched Captain Aungswa to attack the palace and kill the King. Aungswa raced ahead with an advance party and stormed the palace. He found the unsuspecting King and killed him. The Crown Prince had promised Aungswa that he could choose any of the King's first three wives as his own if he were successful. But when the Crown Prince arrived with the entire army, all three Queens rushed to him sobbing and begging him not to give them in marriage to a mere officer in the army. The Prince pitied the women and agreed. He offered a minister's daughter to Aungswa as his reward, but Aungswa merely replied: "Pish!"

This reply angered the new King, which he regarded as an act of insubordination. So he had Captain Aungswa executed. But the King was full of remorse and remembered that Aungswa had served him well, so he was raised to the status of a god and later added to the list of the Thirty Seven Lords.

Captain Aungswa was adopted as the patron of the Army and is often prayed to for protection and courage.

Muang Po Tu

This Nat is usually pictured riding a Tiger. Sometimes he is carrying parcels of tea.

Muang Po Tu was a merchant of Chinese extraction from the town of Pinya. He often travelled the Shan plateau, climbing north to China to buy tea and sell it in Burma. One day on his return from China, he met with an untimely death, coming across a hungry tiger. The tiger took one look at this portly

gentlemen and had him for his dinner.

Muang Po Tu has become the guardian Nat of traders and businessmen.

Lord Aungpinle, Master of the White Elephant

Lord Aungpinle is always pictured riding his white elephant. He is dressed in royal attire and sometimes carries a staff in one hand.

Aungpinle is the name of an ancient lake near Ava, Mandalay, which means Sea of Victory. Lord Aungpinle was King Ava Thihathu, who reigned in 1422. He was a handsome man and loved chasing women, philandering throughout his kingdom. But he had a jealous Queen, and she pleaded with him to stop all this nonsense. He would merely smile and charm his way around her. She grew tired of these misdeeds and planned his death with one of his Shan Chiefs.

The King was supervising the building of a canal near the lake of Aungpinle, and he always rode his favorite white elephant. Each day he went down to the lake to watch the maidens taking their baths or washing their clothes. The Shah chief hid in the bushes waiting until the sun started to cast long shadows, then he shot the King with an arrow. The King fell from the white elephant, mortally wounded, right into Lake Aungpinle. From that day forth, he was known as Lord Aungpinle, Master of the White Elephant. One of the King's favorite concubines, Lady Bent died of grief, and she was also raised to status of a Nat with her lover.

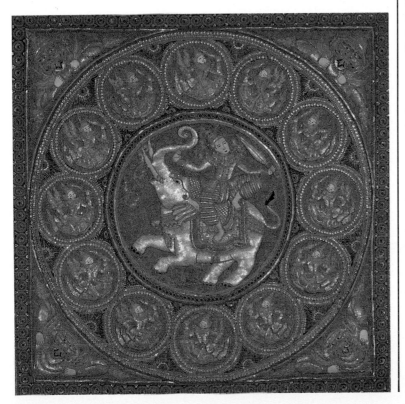

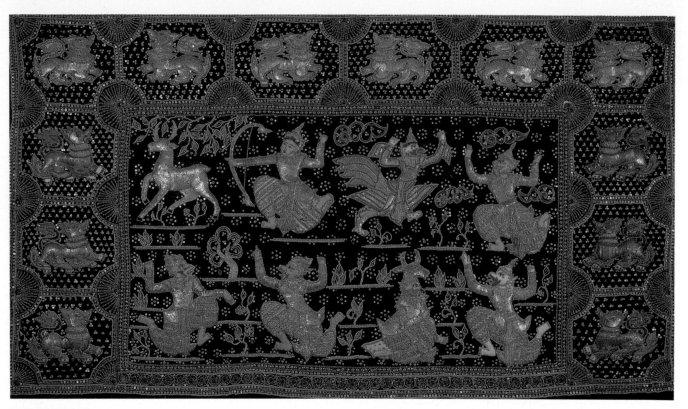

THE RAMAYANA, new

THE RAMAYANA

The Ramayana is an Indian epic written over 2,000 years ago, by a poet named Valmiki. This work was written in Sanskrit, but it has inspired more poets, dramatists, painters and dancers than any other work in Southeast Asian history. Each country adopted its own version for their literature, dances, shadow plays, temple murals and kalagas. This long epic weaves a tale of romance, intrigue, war and finally the triumph of good over evil. I have only given a very short summary of the story. It should be read in its entirety to appreciate the beauty.

The main characters are as follows:

From the city of Ayuddhya, in the world of men and animals:

Prince Rama, the hero
Princess Sita, the heroine
Hanuman, the white monkey general
King Palee, the green monkey, uncle to Hanuman
Sugriva, the red monkey, uncle to Hanuman
An army made up of monkeys and bears
Ravanna, the ten headed demon
An army of giants

Rama and Sita are banished to the forest by a jealous step-mother who wished her son to reign. With them went Rama's brother, Lakshamana with Sita to follow a golden deer, which was the demon Ravana. Ravana, in the guise of a hermit, spoke to Sita. When she approached fearing no danger, he grabbed her and ran off with her to Lanka. A large bird, Rama's friend, saw Sita being carried off by Ravana. The bird tried to save Sita, only to be mercilessly attacked by Ravana. It fell to the ground and fought off death, waiting for Rama to find it, in order to tell him how to find his wife.

Ravana took Sita to Lanka and put a thousand guards at the door to guard her. In the meantime, Rama returned with Lakshamana and couldn't find Sita anywhere. They roamed until they found the dying bird who told them what had befallen Sita.

Rama planned to travel to Lanka to fight the giants and save Sita. Hanuman heard of this when he left his uncle's palace and roamed the forest. Soon his other uncle, Sugriva, would join him to escape from the jealous King Palee.

One day, Hanuman saw two men asleep under a tree and thought that this may be the famous Rama so he changed himself into a small monkey and threw stones at them to wake them up. Recognizing Rama, he came down and paid homage to him, offering his services to help save Sita. They raised an army of men and monkeys and started to march toward Lanka. Rama sent Hanuman ahead to tell Sita of his imminent arrival.

Hanuman found Sita and made sure that she was all right. He set fire to Lanka and left to find Rama again. When the army approached the water, no bridge would be long enough or strong enough to hold them, so Hanuman expanded his body to form the bridge. Many battles ensued, and finally Sita was saved. They returned to Ayuddhya, but were soon faced with evil tongues questioning Sita's virtue. Rama found no other recourse but to banish her to the forest.

Soon after her arrival in the forest, she gave birth to two sons, and the boys grew up to be excellent marksmen. Rama heard of them and sent Hanuman to seek them out, but they escaped, so he sought them out himself. Rama fought them but could not overcome them. He threw down his weapons and asked them who they were. They told the King that their mother was Sita, and Rama realized that these

were his sons. He asked them to take him to their mother and begged her forgiveness, but Sita refused. Sad Rama returned to the palace, thinking of Sita and his two grown sons.

A year passed, and Rama still nurtured the hope that Sita would forgive him. The gods in heaven worried about these two, so Vishnu descended to reconcile them. Sita returned to the palace with Rama, bringing their sons also, to live out their days happily as King and Queen of Ayuddhya.

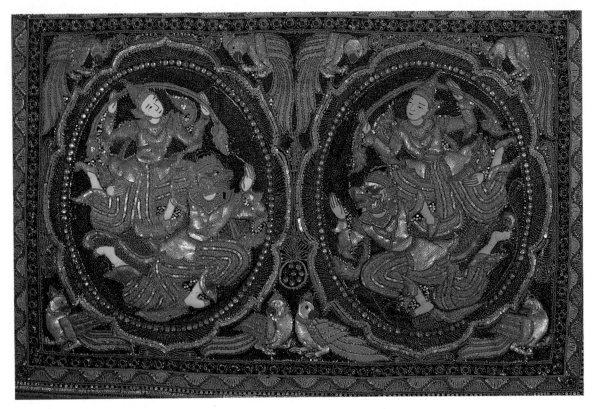

RAVANA AND RAMA FIGHT.
SCENE FROM THE RAMAYANA,
new

FOLK TALES

Each country has its own folk tales and sometimes, regional traditions and culture are added to the tale to make it more believable. Most folk tales were passed on by word of mouth. When the sun has set in the countryside of Burma and Thailand, one can still hear the village story teller narrate tales of olden times. Many have been transformed over the years but they tend to improve with each telling.

In Burma, the following tale is commonly a dance, and it tells the story of two young lovers:

THE RETURN FROM TAXILA

A handsome young Prince attended a school for princely arts in Taxila, a kingdom neighboring his own. His lovely bride had accompanied him to Taxila and had to return to his kingdom with him, but they had no transportation.

The poor Prince and Princess were forced to go on foot. For miles they walked, through towns along dusty dirt roads full of stones. The Princess soon tired and could not walk any longer. She sat down to rub her feet and the Prince serenaded her with songs of the beauty that surrounded them, so that she would forget her pain. After a short rest, they tried to continue, but the Princess's blisters were too painful and she fell down.

The Prince realized that his bride was far too tired and carried her the rest of the way back to the palace.

DANCING PRINCES, new

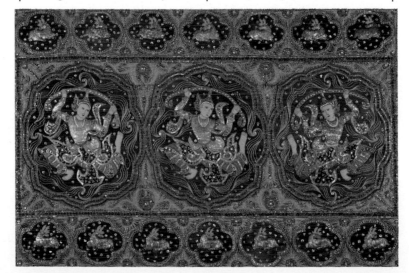

IX

CEREMONIES

The only ceremony that is featured very often in Kalagas is the annual Ploughing Ceremony.

The Annual Ploughing Ceremony

Each year around the middle of May, the Ploughing Ceremony is held in Bangkok, in front of the Grand Palace, on the Phramane grounds. This ceremony is a Brahmin one which has been celebrated in India, China, Cambodia and Burma since ancient times. In a passage of the Ramayana, reference is made to this ceremony, when Sita, the heroine of the story is found in a furrow. In the life of Prince Siddhartha, this ceremony is also mentioned.

The King, or in modern times, the Minister of Agriculture, must be present to plough. Three furrows are made in the ground, in circular motion. At the end of each circle, trumpets and conch shells sound. Rice blessed by the Brahmin priests is ritualistically sown in the earth, as the priests pour lustral water over the sown seed. The coming harvest of the rice crop is then predicted. When the ceremony is over, farmers from all over the land try to get a grain of the King's rice to sow with their own rice, believing that it will bring them a better harvest.

THE PLOUGHING CEREMONY, new

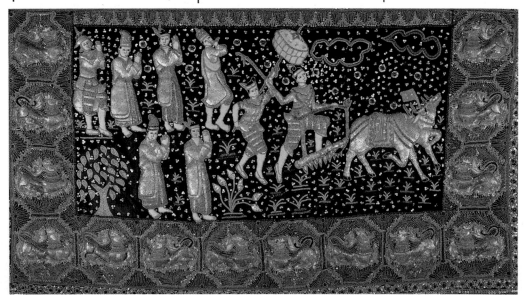

MYTHICAL ANIMALS — BEINGS

HAMSA OR HINTHA BIRD — HONG

In Hindu mythology, this bird is the vehicle of the Lord Brahma, when he descends to the earth. Perhaps from this early mythology did it appear. In Burma, it was adopted by the Mons as their heraldic symbol for their kingdom in Pegu, also called Hamsavarti. The Mons believed this bird to be the ideal representative of the qualities of purity and gentleness.

The legend behind Pegu is an amusing one. Long before Pegu existed, there was a patch of land that only appeared when the sea was at low tide. A pair of hamsas were flying overhead and wished to stop. The male landed first, leaving no room for his mate, so she perched herself directly on his back. It is still said of the women of Pegu, that they henpeck their husbands!

In Thailand, a similar type of bird exists, but it resembles a swan more than a goose. It is called the Suwannahong or just hong. During the Ratanakosin period, it was very popular to have these birds as bronze statues around the temples. The King's royal barge is in the shape of this heavenly goose.

Both versions of this animal are popular themes in the kalagas.

HAMSA new

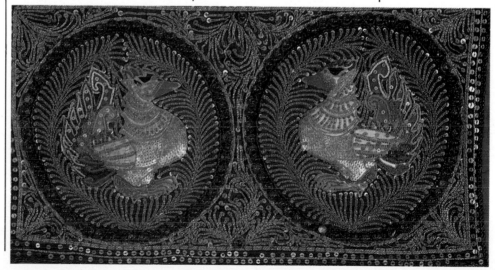

Naga

The Naga is a mythical snake, about the size of a python, with either five or seven hoods. Nagas are said to dwell in rivers and oceans, or in the bowels of the earth, in a land of luxury. They are believed to have magical powers, and bring rainfall. Often they assume the form of a human to visit the earth.

Often you will find Buddha images with the Naga coiled around the base, his hoods creating an umbrella to protect the Buddha. According to the legend, after the Buddha was enlightened, he sat under the Bodhi tree meditating. Many days and nights he sat meditating, when suddenly a cold rain fell from the skies. King Mucalinda, the Naga King came up to the earth and coiled himself around the Buddha in seven coils and spread his seven hoods over the Buddha to protect him from the wind and rain. When the rain ended, the Naga uncoiled himself and stood in front of the Buddha, disguised as a young man to pay his respects.

In Thailand, Nagas are featured at the entrance and on the long bannisters of monasteries and temples. Nagas are supposed to be responsible for pro-ducing water in the sky to rain down onto the earth. Each year, the number of Nagas hovering above the earth will determine the quantity of rainfall. One of the King's royal barges is made in the shape of a Naga.

Garuda or Galon

The Garuda or Galon is a mythical animal, half-bird and half-man. The head, wings, talon and beak resemble the eagle, but the body and limbs resemble man. They are believed to be the mortal enemy of the Nagas, and are featured in many of the epics and legends fighting the Nagas.

In Thailand, the Garuda is a symbol of royalty.

Singha or Chinthe

The singha or chinthe is a mythical lion that has become the guardian of the temples in Burma and Thailand. In the Vessantara jataka, a lion is sent to detain Maddi in the forest so that she will not see Vessantara give her children away.

SINGHA OR CHINTHE, new

56

White Elephant

The white elephant is actually an albino elephant. It has been a symbol of prosperity for centuries in Asia. Any kingdom which possessed more than one was a very prosperous one. Throughout the history of Southeast Asia, wars have been fought over white elephants.

The legend has its roots in Hindu mythology. In the epic, the Mahabharata, Airavata, the milk white elephant emerges from the milk of the universe during the churning of the seas. It is believed that all white elephants are descendants of the famous Airavata. They are supposed to be endowed with the magical power to produce rain clouds. This was an important power during ancient times in Asia, where the monsoons were essential in helping the crops to grow after the scorching summers. If the rains didn't fall, drought was the inevitable result, with famine to follow.

In one of the 550 lives of the Buddha, he was born as a white elephant. For this reason too, the white elephant is still respected today. In Thailand, when a white elephant is born, it is presented to the King.

Manusiha

This is a mythical creature that is half-lion, half-man. He has the torso of a man and the double body of a lion. This figure is found in Burma around the grounds of the temples, on the corners of the pillars, and is a guardian.

In Hindu mythology, Vishnu was challenged by a demon king called Golden Garment. Vishnu disguised himself as a half-man, half-lion and emerged from the demon king's pillar to kill him.

MANUSIHA, new

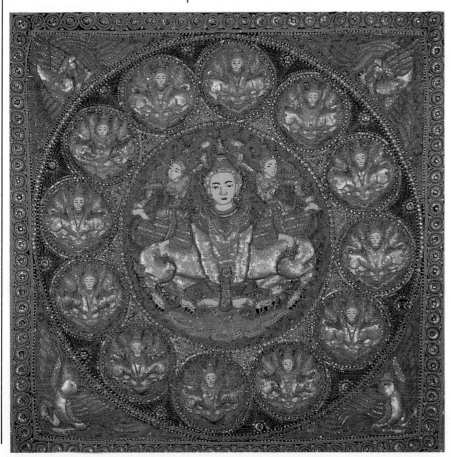

Deva

The Deva is believed to be a celestial being of exquisite beauty and grace. They live in the heaven of sensuous pleasures and delights. Born of spontaneous uprising, they never age, guarding youth and beauty. They are minor deities and are often depicted in kalagas, standing on lotus platforms or flying through the sky. Their visits to the earth are usually to help or protect certain people or as messengers for the gods.

DEVA, new

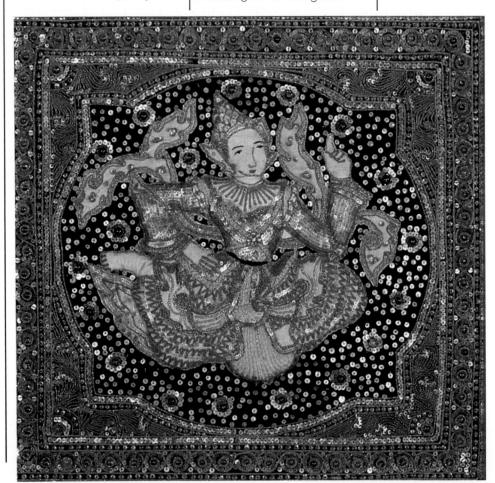

XI

ANIMALS

Most animals have already been mentioned in the Gods of the Planets, the Animals of Buddhist Years, or in the Horoscopes. The following animals are common motifs that have other meanings than those mentioned above.

Crocodile

The crocodile is featured in many Thai and Burmese legends. It is an animal to be feared, like the tiger, and killing one is considered quite a feat. In one Burmese tale, a young Prince befriended a crocodile and rode on his back to cross the river. One day, as the Prince stood on the crocodile's back, a storm sprang up from nowhere. The crocodile told the Prince to climb between his jaws, whe he would be safe. The Prince couldn't trust the crocodile. He fell into the river and drowned.

Deer

The deer has been an integral part of mythology in Asia for at least 2,000 years. In the Ramayana, there is an important scene in which Ravana disguises himself as a deer to attract Sita, the heroine of the story.

In the early Buddhist scriptures, reference is made to the deer as the symbol of the Buddha's word and teaching. It was not until about nine centuries after the Buddha's death that caste images were made of him. One of the most famous teachings of the Buddha was delivered in the Deer Park.

DEER, new

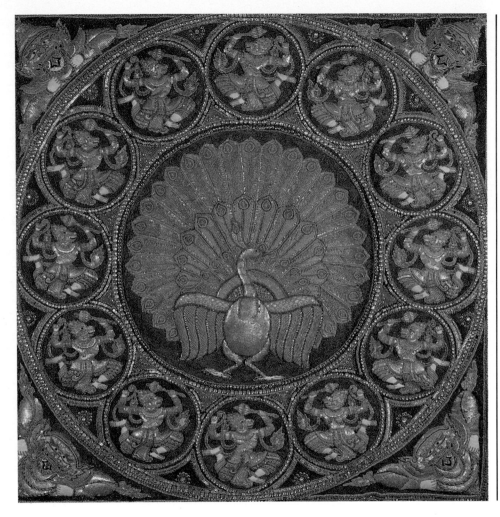

Parrot

Usually parrots are used in Kalagas for borders. They portray the bird kingdom, and the beauty that is associated with it. Parrots were wild in Burma and Thailand. In some kalagas, the parrots are larger than the men. This is the realm of make believe, and size is often up to the artist.

Peacock

The peacock and peahen have long been symbols of beauty in Asia. The peacock dance exists in China, India, southern Thailand and Malaysia. In Burma, the peacock is a symbol of the sun. It was adopted as the royal emblem during the Konbaung Era (1752–1885). As a royal symbol it is featured in kalagas, lacquerware, and furniture.

PEACOCK, new

Turtle

In Hindu mythology, Vishnu assumed the form of a turtle in the churning of the ocean. The Buddha once honored the turtle by allowing it to hold his robes together. One day, a snake spoke with the turtle at great length, and as their discussion continued, the turtle forgot his duty to hold the Buddha's robe and fell to the earth. The turtle was hurt in the fall, and the Buddha felt sorry, so as protection, he gave the turtle a hard shell and dismissed him from his duty.

Turtles are kept in most temple grounds in Burma, where they are looked after and fed.

ANIMAL KALAGA, new

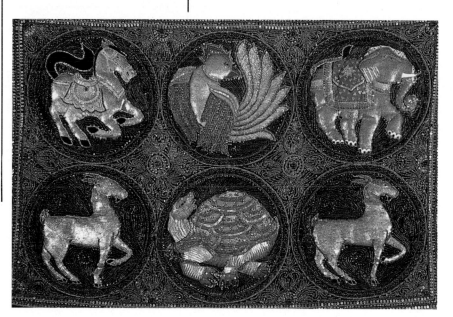

EPILOGUE

If you own a Kalaga, I'm sure that you've already found the story that corresponds to yours. There are some stories that I have not included as I chose only the most popular tales found in the modern kalagas.

After working seven years with these treasures, I am still enthralled to find new designs, colors, and styles. Now that it has become a more common craft, it is important to look for the most exquisite pieces, as these will be the valuable antiques of the future. This artform has been lost before and we have no assurance that it will not be lost again. If this book does nothing but serve as a record for posterity, we will have benefited from it.

ANIMAL KALAGA, new

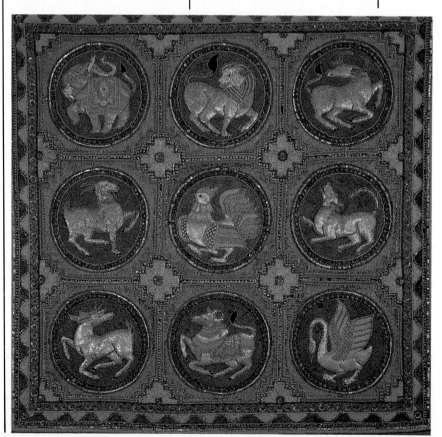

BIBLIOGRAPHY

Aung, Maung Htin. FOLK ELEMENTS IN BURMESE BUD-DHISM. Rangoon: Buddha Sasana Council Press, 1959

Aung, Maung, Htin. A HISTORY OF BURMA. New York and London: Columbia University Press, 1967.

Bhirasri, Professor Silpa. APPRECIATION OF OUR MURALS, Bangkok, Thailand: The Fine Arts Department, B.E. 2502 (1959)

Blackmore, M. THE RISE OF THE NAN CHAO IN YUNNAN

Bunge, Federica M. THAILAND-A COUNTRY STUDY, Washington D.C.: American University, 1981

Cady, John F. SOUTHEAST ASIA, IT'S HISTORICAL DEVELOP-MENT, New York: McGraw Hill, 1964

Chit, Khin Myo, A WONDERLAND OF BURMESE LEGENDS, The Tamarind Press, Bangkok, 1984

Fraser-Lu, Sylvia. BURMESE LACQUERWARE, Bangkok: The Tamarind Press, 1985

Gostelow, Mary, THE COMPLETE INTERNATIONAL BOOK OF EMBROIDERY, Simon and Schuster N.Y. 1977

Hall, D.G.E. HISTORY OF BURMA DOWN TO THE END OF THE THIRTEENTH CENTURY, London: 1958

Hall, D.G.E. A HISTORY OF SOUTH-EAST ASIA, London: Macmillan, 1955

Harvey, G.E., OUTLINE OF BURMESE HISTORY, Longmans, Green and Co., London 1926

Ions, Veronica INDIAN MYTHOLOGY, New York: Peter Bedrick Books, 1984.

Kunstadter, Peter SOUTHEAST ASIAN TRIBES, MINORITIES AND NATIONS, Princton University Press, 1966

Lyons, Elizabeth, THAI TRADITIONAL PAINTING, Bangkok, Thailand: The Fine Arts Department, 1963

Lyons, Elizabeth, THE TOSACHAT IN THAI PAINTINGS, Bangkok, Thailand: The Fine Arts Department, 1963

Mahasadana, Choomsri and others, THE LIFE OF THE LORD BUDDHA from Thai Mural Painting, Asia Books, Co. Ltd, Bangkok, Thailand, 1986

Puls, Hertha THE ART OF CUTWORK AND APPLIQUE, Newton Center: Charles T. Bradford Co. 1978

Rawson, Tessica and others THE CHINESE BRONZES OF YUN-NAN, Beijing, China: Cultural Publishing House, 1983.

Roberts, T.D. and others AREA HANDBOOK FOR BURMA, Washington D.C.: American University, June 1968

Shears, Evangeline and Fielding, Diantha. APPLIQUE, New York, N.Y.: Watson-Gupthill, 1972

Sibunruang, Kasem. SIAMESE FOLK TALES, Bangkok, Thailand: Don Bosco Technical School and Orphanage, 1954

Stewart, A.T.O. THE PAGODA WAR, London: Faber and Faber, 1972

Syamananda, Rong A HISTORY OF THAILAND, Chulalongkorn University, 1986

Toth, Marian Davies. TALES FROM THAILAND, Japan: Charles E. Tuttle Co., 1971

Temple, Sir Richard. THE THIRTY SEVEN NATS, London: Griggs, 1906

Williams, C.A.S. ENCYCLOPEDIA OF CHINESE SYMBOLISM AND ART MOTIVES, New York: The Julian Press Inc., 1960.

Wray, Elizabeth, Rosenfield, Clare, Bailey, Dorothy, Wray, Joe, THE TEN LIVES OF THE BUDDHA, Weatherhill, New York & Tokyo, 1972

In French:
Boisselier, Jean. Beurdeley, Jean-Michel. LA PEINTURE EN THAILANDE, Fribourg: Office du livre, 1974

Plion-Bernier, Raymond. FETES ET CEREMONIES DE THAILANDE, Bangkok: Assumption Press, 1969

Publications:

— Government Printing Office, THE EIGHTH ANNIVERSARY BURMA, Volume VI No 2 Rangoon: January 1956

— Muang Boran Publishing, WAT CHONG NONGSI MURAL PAINTINGS OF THAILAND Bangkok, Thailand: January 1982

— United States Information Service, THE LIFE OF THE BUDDHA Bangkok, Thailand: 1957